RE-IMAGINING MARY

Mariann Burke

August 16, 2009

Re-Imagining Mary

A Journey through Art to the Feminine Self

Mariann Burke

Fisher King Press

www.fisherkingpress.com

info@fisherkingpress.com

+1-831-238-7799

Re-Imagining Mary: A Journey through Art to the Feminine Self
Copyright © 2009 Mariann Burke
First Edition

Published simultaneously in Canada and the United States of America. For information on obtaining permission for use of material from this work, please submit a written request to: permissions@fisherkingpress.com

ISBN 978-09810344-1-6

LCCN 2008934078

Cover image: Václav Boštík, *The Virgin and Infant Jesus*, (Oil on cardboard 50 x 30 cm.) Photograph © National Gallery in Prague, 2008.

Contents

Acknowledgements IX

Foreword by Nancy Qualls-Corbett XI

Introduction 1

Revisiting Fra Angelico's Annunciation 13

Picturing the Annunciation 37

Discovering Mother Mary 73

Imaging Mary as Temple 99

Sounding the Stone Dream 127

Coda 143

Bibliography 151

Index 159

For Bobbie, Kathleen, Patti, and Sheila
and in memory of
E. J. Greco

ACKNOWLEDGEMENTS

I am grateful to many who helped to bring this work to completion by reading part or all of the developing manuscript and by offering suggestions, encouragement and support: Paola Biola, Aileen Callahan, Judith and Dennis O'Brien, Anne Baring, Bob Baer, CSP, Cornelia Dimmitt, Jane Schaberg, John Peck, Ed Burke, Gail O'Donnell, RSCJ, Aline Wolf, Johannes Schatzmann, Margarita Cappelli, RSCJ, Helga Schier, Meg Guider, OSF, Russell Holmes, Daniel Burke, FSC, Kathrin Asper, Susan Tiberghien, Fred R. Gustafson and David Oswald. I thank the staff at Bapst Library, Boston College, especially Adeane Bregman and Arlene Feinberg, who generously offered help with art references. For their fine editing I thank Joseph Pagano and Patty Cabanas. Finally I am most grateful to Mel Mathews for his cooperative spirit, sensitivity, and patient guidance throughout the process.

FOREWORD

For two millennia throughout all Christendom the image of the Blessed Virgin Mary has been adored. From the lofty world's cathedrals to the smallest Christmas crèche that adorns a humble family dwelling her representation is present. Anthems are sung to her, voices are raised to praise her name, her very being. And yet standing back with some reflection, are we consciously aware of a deeper, more significant meaning of Mary? In re-imagining Mary, may we broaden our understanding of the profound psychological value her image holds for us.

Some years ago I was privileged to visit the caves at Lascaux in France to view the magnificent, bigger than life, prehistoric cave paintings. These depictions of noble beasts were majestic; some only in outline while others were painted in intricate detail with pigments made from minerals of the earth. I physically felt as I sensed this deep underground cave that it was permeated by the instinctual spiritual wisdom of twenty thousand years. It was as though the cave paintings were primitive man's first expression of his soul. A numinous sense surrounded me as I knew myself to be in this holy place. It was not so surprising after such an awe-inspiring experience that I had a dream the following night. The dream was this:

> I was once again in the cave of Lascaux filled with wonderment while viewing the paintings of wild animals on the walls and ceiling. Directly in front of me on the cave wall I began to see a bare outline of a figure as if scratched into the wall. And then the outline became emboldened in black charcoal as if painted by unseen hands. While I continued to look with amazement, the figure began to take on more definition and color. I then realized I was viewing the image of the Virgin Mary... there on the wall of a most primordial setting.

I awoke from the dream with a start. As my conscious mind was reviewing the detail, the image of Mary created more than a little discomfort within me. I realized I had envisioned, in sym-

bolic form, the archetypal aspects of the divine feminine nature. There in the earth's womb-cave, ever so deep and dark in the realm of the collective unconscious, was the image of the Great Mother, which we most often in our Christian culture depict in our mind's eye as the blessed Mother of Christ. We continue to look upon her image to understand her meaning in our modern day life, aspects of the feminine in our own psychologies.

Through the centuries the idealization of the blessed Virgin perhaps has inspired more masterpieces of art and great architecture than any living figure, as author Mariann Burke beautifully explores in the following pages. We see her as the youthful, blissful and serene Madonna, her adoring gaze on her infant child. Her slender fingers caress the child, as her long, slim neck turns gracefully arching downward. Or we see her as the Mater Dolorosa, the Pieta, her face wracked with pain and anguish or with a far away gaze of contemplative surrender. We also know her from myths and works of art as the Queen of Heaven seated on her throne or standing on the crescent moon with the milk flowing freely from her breast forming the Milky Way. We know of the lofty cathedrals painstakingly crafted throughout centuries that were erected in her honor and which bear her name. There is no question that her image has inspired artisans throughout all Christendom as did her image evoke prayers and supplications from kings and peasants alike. In our Christian mythology it is Mary's image that may be experienced as the archetypal mother goddess, the good breast, comforting and nurturing.

Pope Pius XII's proclamation in 1950 that Mary was taken up, body and soul, into heaven could not have been received with more understanding and joy than by Dr. Carl Jung. He writes:

> When in 1938 I originally wrote this paper, [Psychological Aspect of the Mother Archetype] I naturally did not know that twelve years later the Christian version of the mother archetype would be elevated to the rank of a dogmatic truth. The Christian "Queen of Heaven" has, obviously, shed all her Olympian qualities except for her brightness, goodness and

eternality; and even her human body, the thing most prone to gross material corruption, has put on an ethereal incorruptibility...The relationship to the earth and to matter is one of the inalienable qualities of the mother archetype. So when a figure that is conditioned by this archetype is represented as having been taken up into heaven, the realm of the spirit, this indicates a union of earth and heaven or of matter and spirit.[1]

Our ancestors had already expressed in their paintings praising Nature, as the caves of Lascaux demonstrate, this longing for union of matter and spirit. However, these primitive paintings today are becoming endangered, if not destroyed, by the presence of a pernicious fungus obscuring or even obliterating them. We, too, in our present day culture have all but lost the true image of Mary. It has become obscure to us through insidious means. Through patriarchal edicts Mary has been relegated to the adoring or grieving mother, the mother who was declared a virgin, meaning asexual. We often take her story literally, and ignore the symbolic, the psychological realm. She has been relegated to less than the whole of the Great Mother archetype, the feminine reflection that is sensuous and fertile, an icon of woman who is earthy and who is one-in-herself.

As author and analyst Mariann Burke wisely guides us and reawakens us to a renewed vision of Mary, we consciously begin to understand the extent of what her image embodies.

NANCY QUALLS-CORBETT

1 CW, Vol. 9i, pars. 195-197. (CW refers throughout to *The Collected Works of C.G. Jung.*)

Re-Imagining Mary
A Journey through Art to the Feminine Self

Painting has within it a divine power.
—Battista Alberti

This book is about meeting Mary in image and imagination. It is about the Mary image mirroring both an outer reality and the inner feminine soul. My first meeting with Mary began with an experience of Fra Angelico's *Annunciation* (Cortona). I cannot account for my unusual response to the image except to say that, at the time, over twenty years ago, I was studying Jungian psychology in Zürich, Switzerland and was then probably more disposed to respond to the imaginal world. One day as I sat in my basement apartment reflecting on a picture of his *Annunciation,* energy seemed to surge through me and lift me above myself. Tears brought me to deep center.

It does not matter whether my experience was religious or psychic. The two are very similar since any religious experience always affects our psyche and changes it. It was as if I was restored to my truest self. This was an awakening for me, not an ecstasy. Far from *leaving* my body-self, I seemed to recover it. At the time I had no desire to study Art History or Iconography. Instead, wishing to stay in the world of the symbolic, I returned to the Biblical inspiration for the image in St. Luke.

This is what St. Luke tells us about Jesus' conception:

> In the sixth month the angel Gabriel was sent by God to a town of Galilee called Nazareth, to a virgin betrothed to a man named Joseph, of the House of David; and the virgin's name was Mary. He went in and said to her, "Rejoice, so high-

ly favored! The Lord is with you." She was deeply disturbed by
these words and asked herself what this greeting could mean,
but the angel said to her, "Mary, do not be afraid; you have
won God's favor. Listen! You are to conceive and bear a son,
and you must name him Jesus. He will be great and will be
called Son of the Most High." (Luke:1:26-38)

I had read this passage many times but it was soon to take on
richer meaning.

Since we know nothing of Jesus' conception and birth, leg-
end and myth "fill in." The word 'myth' comes from the ancient
Greek word 'mythos' meaning 'word.' Both 'logos' and 'mythos'
mean 'word.' While 'logos' refers to rational thinking, 'mythos'
describes poetic or intuitive thinking. "Biblical accounts of Je-
sus' birth and resurrection are 'mythos.' Biblical historical facts
of his life are 'logos.' Both are true."[2] Myths or mythos express
truth closer to life's meaning than facts. Myths resonate in the
soul. For example, stories about the quest for the Grail resonate
with all "searchers." We long to experience the Holy, the numi-
nous. The Annunciation, the birth in the stable, the shepherds'
adoration, and the journey to Egypt, all of these give valuable
insights into *our* personal spiritual journey. And the artists who
have painted these scenes have provided us with "windows"
into depths unknown perhaps even to them.

Some of these "windows" would eventually open for me into
other images of Mary, as Virgin Mother, Black Madonna, and
Wisdom Sophia. But, at that moment down in my basement
study, I was captivated only by the *Annunciation*. I longed to
see other artists' versions of the scene. In Milan, Arezzo or Flor-
ence, I sat in churches just looking at sculptures and frescoes. In
museums, I marveled at the number of artists who had painted
the scene with such depth, delicacy and power. Now these im-
ages of Mary, masterpieces from another age, stirred something
vital within me. Writing these pages helped awaken me to their
personal and symbolic meaning.

2 Seminar notes by Dr. Richard Naegle, Guild for Psychological Stud-
ies, San Francisco, 1995. In St. John's Gospel "Logos" refers to the
eternal existence of the Word. See also Karen Armstrong, *A Short
History of Myth*, p. 31.

Over many years of paying attention to images from my unconscious in dreams and in artistic works, I was beginning to "see" a connection between the image and myself. I had known that through the history of Christianity there have been two ways of interpreting images or symbols: the historical and the poetic or imaginative. I had been exposed to the historical or literal. Now I began to realize that the two are not mutually exclusive. Early Christians honored both approaches but the historical and literal gradually took precedence. In this view the Annunciation is something that happened in the past. In the poetic or mythic approach, we are not so much *viewing* an image as *experiencing* it. My personal experience and my study of Jung would open me to see the Annunciation not as history, but as something happening *now*.[3] Taken in this way, the image reflects something within me. Like a dream, the image *is happening within*.

Certainly this is not new, for mystics of every religious tradition are "seers." And the early Christian Gnostics valued the inner knowledge of God, but they were regarded as heretics. The thirteenth century Dominican Meister Eckhart suffered a similar fate for expressing his beliefs that God and the soul are somehow united. One of Eckhart's favorite sayings found in his sermons is that the Divine Birth is always happening. If it does not happen within our soul, of what value is it? This insight we find echoed in the writings of Angelus Silesius, a seventeenth century mystic, speaking of the Annunciation:

> If by God's Holy Ghost thou art beguiled,
> There will be born in thee the Eternal Child.
> If it's like Mary, virginal and pure
> Then God will impregnate your soul for sure.

> God make me pregnant, and his Spirit shadow me,
> That God may rise up in my soul and shatter me.

> What good does Gabriel's 'Ave, Mary' do
> Unless he give me that same greeting too?[4]

3 Joseph Campbell, *The Mythic Image*, p. 58.
4 C.G. Jung, *Mysterium Coniunctionis*, CW, Vol. 14, p. 319.

Here the mystic part of us contacts that imaginal world that
philosopher Henry Corbin describes as a world between the sen-
sory and the spiritual, just as real as the world of sense and in-
tellect. In this imaginal world something that is not us "comes
to us as an 'I' and addresses us as a 'you'."[5] Experiencing the
image thus personally can initiate us into life altering change.

Theologian Paul Tillich describes such a change. After spend-
ing years in the trenches during World War I, he found himself
one day in a Berlin Museum where he came upon a painting of
the *Virgin and Child* by Sandro Botticelli. He writes:

> The moment has affected my whole life, given me the keys for
> the interpretation of human existence, brought vital joy and
> spiritual truth. I compare it to what is usually called revela-
> tion in the language of religion.[6]

Tillich's experience speaks to the power of image. Many people
have such experiences though they may never articulate how
or in what measure the image changed them.

Meeting Mary in Fra Angelico's *Annunciation* jolted me into
accepting, at least momentarily, that Gabriel's "Ave" was ad-
dressed to me, too. A numinous presence had "graced" me. Had
I never experienced God's presence before? I felt that I had. But
this psychic/religious event opened another layer of "descent"
to self and Self, (Jung's expression for the God-image within
us). I realize that my emotional response to the Annunciation
image in that Zürich basement carried with it the seeds of fur-
ther exploration into deeper realms. My soul "spoke" awaken-

5 Ann Bedford Ulanov, *The Healing Imagination: The Meeting of Psyche
 and Soul*, p. 37.
6 Quoted by Marcus B. Burke, "Why Art needs Religion, Why Religion
 needs the Arts," in Ena Giurescu Heller, ed., *Reluctant Partners, Art
 and Religion in Dialogue*, p. 148. Referring to the power of art, Jun-
 gian analyst Donald Kalsched quotes Michael Eigen: "At times, art
 or literature brings the agony-ecstasy of life together in a pinnacle
 of momentary triumph. Good poems are time pellets, offering places
 to live emotional transformations over lifetimes. There are moments
 of processing, pulsations that make life meaningful, as well as mys-
 terious. But I think these aesthetic and religious products gain part
 of their power from all the moments of breakdown that went into
 them." *The Inner World of Trauma*, p. 126.

ing me to a life beyond the narrow boundaries of tribe, family and Church. My childhood religious faith served me by filling a need for assurance and security. As a young adult I had lived the rigors and beauties of life in a cloister: its silence, discipline, work, service and prayer. Yet I sensed at times that I knew nothing of God and less of myself! I was maturing, becoming more conscious.

An important aspect of this maturing was sensing God in the depth of my soul. Jung's theories helped me here, but for many years remained intellectual insights rather than experienced realities. Jung called the deeper dimension of every human being "a potential world, the eternal Ground of all empirical being."[7] Of great importance in Jung's development and the formulation of his theories was his dream of a two storied house recounted in his autobiography, *Memories, Dreams, Reflections.* The dreamer descends from the top floor furnished in rococo style. Each floor reveals older furnishings, the next lower looks medieval. A heavy door opens out to a stone stairway leading to a cellar. Here the dreamer discovers a floor of stone-block seemingly from Roman times. Descending to a still deeper level, the dreamer discovers a few skulls and broken pottery that seemed to represent pre-historic times.

What an impression this dream made on him! Could these many layers refer to the psyche? Jung began to study archeology and world mythologies and symbols. As a psychiatrist working with the mentally ill and as a psychoanalyst in private practice, he began to note similarities of images in dreams and fantasies. He interpreted this to mean that in our soul's depths there exists a layer common to each human being containing remnants of how our early ancestors experienced life. The psychic "organs" on this level he called archetypes, energetic presences "engraved" on the soul. These are predispositions to respond in certain ways to life situations. Surely these instincts are stirred when we fall in love, when we witness a birth or a death. We are "moved."

7 *Mysterium Coniunctionis,* CW 14, p. 534.

At these depths we are one human family. This is the world of Oneness which Jung intuited as feminine, as inexhaustible fecundity. Priest theologian John Dourley writes that, by *implication* this soul or "matrix" can be called the Great Mother, *the* Goddess. For "in her numinous form it is she who creates, destroys and renews human consciousness, and who shapes the ground movement of human history, personal and collective, in her efforts to become ever more fully incarnate in it."[8]

Symbolically speaking this "Ground" is feminine, ever renewing. This "matrix" is imageless, but she is symbolized as Great Mother, ocean, nature or soul. What qualities do we attribute to the "feminine?" In our daily life we describe our feminine nature as creative, fertile, caring and loving. Feminine power acts from compassion; it is receptive not controlling, yet this power, when it is not respected, has a destructive side. Mother Nature can go on a rampage inflicting suffering and death. Does she take revenge when she is ignored? Another side of this destructive power appears as regenerative. Like the moon, the oldest symbol for the archetypal Feminine, fertility, birth, death and rebirth are mirrored in her waxing and waning cycles. The Feminine often destroys old forms to make space for something new.

Is it this stirring of the new that the feminine spirit is awakening in our search for new spiritualities? Does this mean a recovery and revitalization of the great psychic truths, the mythic images of our religious traditions? I believe so. The image of Mary as Divine Feminine continues to inspire millions as a Goddess figure, symbol of justice and liberation of the poor, compassionate Mother and Wisdom. The historical Mary needs to be recovered from a view that sees her as meek, weak and totally submissive to male authority rather than to her inner feminine authority.

In her book, *In Search of Mary,* Catholic writer Sally Cunneen points to this broader approach to Mary:

8 John P. Dourley, *The Goddess, Mother of the Trinity: A Jungian Implication,* pp. 46-47.

> In looking for Mary we are looking for ourselves... Mary is not exclusively Catholic or Jewish, Western or Eastern, but a sign of what men and women can be when they participate in the ongoing mystery that links the divine to all that is.[9]

It is that mystery that I want to explore in these pages as I re-imagine depictions of Mary.

I approach them as life giving and strengthening images, for the master artists create from the unconscious depths and we meet that depth within ourselves. Thus, throughout this work, I will be shifting from the outer image or painting to the inner Source, the psyche, which, because of its limitless fecundity, Jung named Maternal. Jungian analyst John Dourley writes that it is the recovery of this inner depth, honoring it as the Great Feminine Source of All, which saves us from living shallow and inauthentic lives. This recovery "calls for a new spirituality (as a) re-rooting of the modern soul in its native divinity."[10] Jung has described our contemporary rootlessness as one-sidedly intellectual:

> But consciousness, continually in danger of being lead astray by its own light of becoming a rootless will o' the wisp, longs for the healing power of nature, for the deep wells of being and for unconscious communion with life in all its countless forms.[11]

For when we become rootless, we lose our way.

Certainly I was "losing my way" when I went to Zürich. What was I searching for if not for my "roots," the connection

9 Sally Cunneen, *In Search of Mary: the Woman and the Symbol*, p. 24. Implied here is Mary regarded not only as historical but as archetypal (that is, she carries the energies of the Great Feminine, the archetypal Great Mother.) See Baring and Cashford, *The Myth of the Goddess*, pp. 554-5. Also see Andrew Greeley, *The Mary Myth*.

10 John P. Dourley, *A Strategy for a Loss of Faith: Jung's Proposal*, p. 94. This is a heretical statement to those for whom religion is revealed by a transcendent God who descends into history. For Jung a God who wants to be so intimately united with the soul cannot be totally "Other." Jung suggested that anyone who doubts that God is in the psyche, the origin of our metaphysical ideas and organized religions, should "take a reflective tour through a lunatic asylum." (*The Symbolic Life*, CW, Vol. 18, par 1506.)

11 *Symbols of Transformation*, CW, Vol. 5, p. 205.

to my true spirit? Are not our religious institutions meant to be conduits of the Spirit, enabling us to recognize the incarnating God within? When they fail to do this, we feel weary, hungry, disoriented. Even the honored great images and rituals seem to grow sterile. And yet the Spirit is present, and often, while meditating on a well-known image, I feel that She imparts a new energy, reawakening something "dead" or "sleeping" in my soul. Perhaps in viewing the Annunciation image I felt *a new possibility, an expectation that new energy would miraculously well up from within.*

I wonder how women who have been drawn to this image can enter into it so that it yields its treasures for each of us personally. How can we resonate to the image as a mirror of our life experience? And a key question for each of us, how can we free ourselves to reimagine the image, weaving a story more in tune with who we are? How can the Annunciation awaken us to ourselves *fully human,* made in God's image, "temples" of God, beloved of God, *loving our self?* I began to see that re-imagining religious images expands and enriches us, releasing life-giving water to quench our soul-thirst, deepening our faith in the spirit living within us.

My reflection on the Annunciation image led me further into the mystery of God and the need for an epiphany of the Divine Feminine as a mirror of myself as woman. With no "sacred" female image how can women and men relate within themselves to dimensions of the archetypal feminine?[12] Mary as Mother and Wisdom began to fill this need for me. I began to feel that in spite of a male dominated church, the traditional Christian symbols and images like the Divine Child or sculptures of the Black Madonna can be mined as treasures, for we inherit them from the great ancestral Soul. "When truly archetypal motifs and figures of tradition cease to be the objects of the devotion to which they have been attached for centuries, the afterglow can

12 Elizabeth A. Johnson, *She Who Is: The Mystery of God in Feminist Theological Discourse,* pp. 61-75. See also Edward Schillebeeckx, *Mary, Mother of the Redemption,* pp. 101-28. The author suggests that maternal qualities of God need to find expression in the figure of a woman, and that Mary as partner to Jesus reflects that dimension.

sometimes seem even brighter than the glow."[13] Reimagining and living from these energies ignites *hope* in a saving power within us, "an afterglow" that never diminishes.

In this "afterglow" I have experienced moments when the historical Mary and the mythic or Cosmic Mary "came together" as I pondered the Marian images of Fra Angelico, Piero della Francesca and Frederick Franck. Contemplating the Black Madonna, I began to sense a creative feminine Spirit, not abstract and "above" but earthy, near and mothering. My attraction to the historical Mary lay in her faith, her courage, and her strength. As a symbol, as the Cosmic Mary, she represents the Great Feminine, the Divine Feminine energies that I long to connect with under her titles: Queen of Heaven, Mirror of Justice, Mother of the Universe and Sophia Wisdom.

Many years after my Zürich "experience" of Fra Angelico's *Annunciation* I was able to view the original painting. Chapter One is a reflection on the image and a psychological amplification of the key figures or symbols found therein. Approaching the picture as if it were a dream or inner drama may help expand our self-knowledge and personalize the image. The Paradise story tells us that we are lacking in some way, alienated from our feminine spirit. Thus, psychologically viewed, the Annunciation image reflects our personal journey into wholeness.

My Zürich experience led me to explore other images of the Annunciation and I still enjoy discovering new expressions of this scene in books, museums and churches. In Chapter Two, a "gallery" of favorites with personal associations and reflections shows how each depiction in its way receives and projects back to us something of ourselves, our desires, memories, longings. Before reading the reflections offered, it may be helpful for you to stay with the picture, meditating on its unique approach to the mystery of Annunciation as you imagine its meaning for you today.

13 Jaroslav Pelikan, *Mary through the Centuries: Her Place in History of Culture*, p. 165.

Chapter Three, "Discovering Mother Mary," was inspired by the icon, *Virgin of Tenderness*. My journey through the Annunciation image(s) led me to the recovery of Mary not only as Mother of God, a title from the Judeo-Christian tradition, but to Mother God, a title reaching back to an ancient longing for a Female Divinity. In western Christianity this Mary bears the titles and the qualities worshipped for thousands of years in the Female images of God and Goddess. These titles include Mary as Sorrowful One and as Primordial Mother. Recovering Mary both as light and dark Madonna plays a crucial role in humanity's search for a divinity who reflects soul.

In Chapter Four, "Imaging Mary as Temple" the temple motif is explored as the sheltering Great Mother. Piero della Francesca depicts the living Mary as temple in *Madonna del Parto* and *Mater Misericordia*. Frederick Franck's *The Original Face* and the medieval *Vierge Ouvrante* suggest this motif as Mary both creates and "protects" the mystery of our common Origin. Franck's inspiration for his sculpture of Mary (which he called an icon) is the Buddhist koan, "What is your original face before you were born?"

Chapter Five, "Sounding the Stone Dream," shows how a dream can unfold over years with both personal and collective meanings. The message in my "stone" dream is that collective and personal wounding in the feminine can be healed through a discovery of our divine/humanness. The dream dovetails with multiple levels of art as it reveals a guiding spirit within, the Self.

In the Coda, "Recovering our Spirituality," I return to some questions raised in this book: What is spirituality? What does it mean to grow spiritually and psychologically closer to the Feminine Self? How can we begin to see the "outer" image as a manifestation, a projection of the psyche? Can we be challenged by being "betwixt and between" a male dominated Church without a recognized female divinity, where God is generally imagined external to the soul, and a more feminine depth psychological approach to the Marian mystery and to

the Feminine Self within us? Will we answer the call of the mystic within us? If so, how will we be changed?

Artists plumb the depths of soul which Jung calls the collective unconscious, the inheritance of our ancestors' psychic responses to life's drama. In this sense the artist is priest, mediating between us and God. The artist introduces us to ourselves by inviting us into the world of image. We may enter this world to contemplate briefly or at length. Some paintings invite us back over and over again and we return, never tiring of them. It is especially these that lead us beyond image to the Great Mystery.

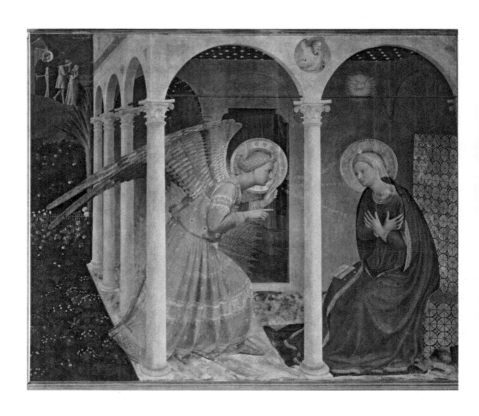

Fra Angelico. *Annunciation* (ca. 1433) Museo Diocesano, Cortona.

Revisiting
Fra Angelico's Annunciation

We need to go down into ourselves to find the meaning of the ar-
chetypal realities that the traditional symbols represent. Otherwise
belief takes the place of our own creativity... we deprive ourselves
of... that which wants to be born in us.

—Elizabeth Howes

We should approach the original painting as if it were "a burn-
ing bush in order to receive its aura," writes literary historian
Walter Benjamin.[14] In 1998 when I traveled to Cortona, Italy,
I eagerly anticipated experiencing the "aura" of Fra Angelico's
masterpiece. Here in this little town not far from Florence, over-
looking the lush Tuscan countryside, I came closer to seeing
that the image is to be aesthetically enjoyed and treasured. And
further, it is not so much to be explained as to be lived, that is,
as if one would discover the Annunciation event within oneself,
like a dream. It is as if the Annunciation story reflects our own
psychic life, its birth and maturing. It is as if God's becoming
and our own meet in a Virgin's "Fiat," empowering us both.
While at Cortona, I basked in the beauty of nature and in Fra
Angelico's painting. To this day my musings on the Annuncia-
tion and my delight in the Italian landscape remain fresh in
my memory.

On my first day in Cortona as I looked outside my window at
the paradisal view below, I saw in the distance what appeared
to be a monastery. Upon inspection I discovered not a monas-
tery but a cemetery enclosed on three sides by massive stone
walls. Each grave was decorated with colorful flowers that alto-

14 Walter Benjamin, *Illuminations*, p. 224.

gether made up one gigantic spring garden. Built into one side of a massive wall were hundreds of receptacles for urns, each decorated with large multi-colored bouquets. The dead seemed very much present like the subtle perfume of flowers pervading the quiet hillside.

That afternoon as I approached the little museum that houses the Fra Angelico *Annunciation* I again found this motif of death and rebirth. On a roped-off pedestal beneath the painting stands an intricately carved octagonal marble baptismal font. I was reminded of the pre-Christian alchemical symbolism that through immersion in water ("death") the neophyte rises to a new level of life. In Christianity the neophyte is "cristified" as child of God. And there above the baptismal font hangs the *Annunciation* representing the Feminine mystery of new birth. Unlike my first meeting with the image in Zürich, I did not cry outwardly, only inside. The image seemed to breathe life into me, a life welling up from far beyond the artist's time or place.

Standing before the painting, I realized that Mary and the angel are so dominant that I had hardly noticed Adam and Eve leaving Paradise. They appear in the upper left hand corner, in miniature compared to the central figures. No doubt Fra Angelico was influenced by an earlier artist, Giovanni de Paolo, whose *Expulsion and Annunciation* was meant to show the cause of a disobedience that resulted in the birth of a Savior. The two scenes are related artistically in Fra Angelico's work by the angel's magnificently detailed and colorful wings which extend through the portico into the garden. Thus the painting expresses the belief in the incarnation of God in Jesus who would save us from the effects of the Fall. The Eden story "explains" why we feel alienated from our roots, why we long for wholeness often expressed as a longing for Paradise.

The familiar Eden story recounts how God forbids Adam and Eve to eat from the tree of good and evil. When the serpent approaches Eve saying that she will *not* die, but rather, will become like God, she eats the fruit and offers it to Adam who eats. Discovered in their crime, they must leave for earth. On earth men would labor by the sweat of their brow and women would

bear children in pain. On earth women were to be subject to men. Was the serpent to blame for it all? Or was it Eve? Given the traditional Christian interpretation of Eve as bad, "the devil's gateway,"[15] and Mary as good, is it possible to arrive at a more holistic view of woman?

There are other versions of the story, interesting and imaginative, kinder to Eve. In Mark Twain's "Diary of Adam" Eve is described as an experimenter. Adam writes, "She has taken up with a snake now. The other animals are glad, for she was always experimenting with them and bothering them; and I am glad because the snake talks, and this enables me to get a rest... I advised her to keep away from the tree. She said she wouldn't. I foresee trouble. Will emigrate." Eve's curiosity is a main theme in *her* "diary." She writes, "Some things you *can't* find out; but you will never know you can't by guessing and supposing: no, you have to be patient and go on experimenting until you find out that you can't find out. And it is delightful to have it that way; it makes the world so interesting." In Twain's view Eve was the first experimenter, and her curiosity brought us to higher consciousness.[16]

Another refreshing story of Eve was told by Rachel Naomi Remen in her story, "Grandmother Eve." As a child Remen listened to her grandfather rabbi describe Eve's life of ease in the Garden and the one prohibition God imposed—that she not eat from "the Tree of God's Wisdom." Curious Eve gave in to the snake's persuading and ate. Far from dying, she absorbed God's wisdom, becoming free, enlightened, and more conscious.[17] When Remen asked her grandfather why God had forbidden Grandmother Eve to eat of the tree in the first place, knowing that she would disobey, he paused before answering this difficult question. Of the many images of God in the Bible, all of them needing our scrutiny, some present Him as loving and compassionate, others as angry and destructive.[18]

15 Tissa Balasuriya, *Mary and Human Liberation*, p. 141.
16 Mark Twain, "Extracts from Adam's Diary," in *The Unabridged Mark Twain*, Vol. 2, p. 527.
17 Rachel Naomi Remen, *Kitchen Table Wisdom*, pp. 273-276.
18 Ibid.

Many of us have not listened to a story that presents Eve or the serpent in such a positive light, as an awakener to new life. I first heard this interpretation many years ago at a seminar on the Bible in San Francisco sponsored by the Guild for Psychological Studies. When Dr. Elizabeth Howes, director of the program and a Jungian analyst, suggested that the serpent could be viewed as another "side" of God, I was shocked. Wasn't God all good and Satan (evil-serpent) all bad? Certainly at that time my religious world view needed broadening. Insights from depth psychology awakened me to unexplored depths within images and dogmas of my Catholic tradition.

One such insight from depth psychology sees the Garden of Eden as representing the original totality or "Womb" from which our ego evolves, separating itself from the original "matrix" to become an entity. The birth of consciousness entails the loss of the original unity and causes pain and a sense of guilt. During this separation from the "womb" the ego continues to be supported by the Self, the center that gives us a sense of order and meaning. This fall into duality places on us the burden of making choices, taking responsibility for them. Psychologically speaking, the forbidden fruit represents consciousness. The serpent, revered by some early Christian sects, symbolizes a force urging birth and growth.[19] Viewing the story as a "fall" into consciousness, it was *necessary* for Adam and Eve to leave the "Womb" of Eden. Thus there is no sin, no one to blame.

Following this insight I find Eve an attractive catalyst for growth, for moving out of the Paradisal "womb," for becoming conscious. Fearful at first of risking punishment from God the Father, Eve takes the plunge, and knows that she has lost the security of the enclosed Garden. She and Adam become real, aware. They are naked. Separated from a state of unconscious unity, they must now experience their new capacity to choose between what they consider good or bad. Choice implies the ability to discriminate. The angel directs them to earth to discover more fully what their life means. Going to earth is not

19 Edward Edinger, *Ego and Archetype: Individuation and the Religious Function of the Psyche,* p. 189.

punishment; rather earth is the place to experience freedom and choice, beauty and suffering, to create and to love.

Thus the two scenes in Fra Angelico's *Annunciation,* the Fall and the Annunciation express separation and union. In one image Adam and Eve separate from God, a kind of death; in the other, Mary and the angel hail pregnancy and new life. May Sarton's poem expresses this death-life paradox:

> In this suspense of ours before the fall,
> Before the end, before the true beginning,
> No word, no feeling can be pure or whole,
> Bear the loss first, then the infant winning;
> Agony first, and then the long farewell.
> So the child leaves the parent torn at birth.
> No one is perfect here, no one is well:
> It is a time of fear and immolation.
> First the hard journey down again to death
> Without a saving word or a free breath,
> And then the terrible annunciation:
> And we are here alone upon the earth.
>
> The angel comes and he is always grave.
> Joy is announced as if it were despair.
> Mary herself could do nothing to save,
> Nothing at all but to believe and bear,
> Nothing but to foresee that in the ending
> Would lie the true beginning and the birth.
> And all be broken down before the mending.
> For there can never be annunciation
> Without the human heart's descent to Hell
> And no ascension without the fearful fall.
> The angel wings foretold renunciation,
> And left her there alone upon the earth.[20]

Bear the loss first, as the child leaves the parent. It seems like a death, this separation and this journey. The "true beginning" comes only after the fall and the descent to earth.

Going to Mother Earth (Gaia) was the next step in the unfolding of the human/divine drama. The angel's annunciation

20 May Sarton, "Annunciation," in *A Grain of Mustard Seed,* p. 61.

does not seem joyful. It foretells more renunciation. The poet seems to speak here both of Mary's future renunciation of self and of Jesus' death. Yet in this is found the paradox of true beginning and birth. Aloneness seems to be a pre-condition for both. Mary's "Yes" and our own "Yes" to God must be said within the solitude of our heart. Without it and its accompanying sense of vulnerability and limitation, there is no annunciation, no destiny greater than one could have imagined—bearing the divine within.

Sarton weaves overtones of the mythic death and life motif that threads through all human life. The depth psychological insight into the Eden story as a "fall" into consciousness, a kind of "death" issuing in new life echoes the Fall and Incarnation theology expressed in Fra Angelico's painting. For me this double lens approach to the dogmas enriches understanding and *experience* of the profound spiritual truths they hold. Without a bridge between our soul and religious images and dogma, the latter remain external and no longer energize us. We project our inner drama to the dogma or image (e.g. Virgin Birth) and see it only as external to our soul.[21] Looking at Fra Angelico's *Annunciation* figures as inner energies may help to build a bridge from dogma to inner individual experience.

Viewing some of the figures in the painting from a psychological perspective, what might they represent as spiritual energies within us *now?* As messenger from the deep unconscious, the angel may bring comfort and challenge; the serpent may stir desire for choice at the risk of disobedience to rules that stifle our spirit. Might Eve be the risk taker in us and Adam the fearful one? Might the Virgin be that part in us open to the healing feminine that mends the split between body and spirit and frees the parts in us still in bondage? The dove, image of transformation, energizes and inspires our creative potential. In Fra Angelico's painting it hovers well above Mary's head closer to the portico ceiling where God the Father, framed within a circle,

21 Ann Bedford Ulanov, *The Feminine in Jungian Psychology and in Christian Theology*, pp. 119-123.

looks down at the scene. In our soul, we can imagine the great dream maker fashioning our night images looking on as well.

I have referred to my early meeting with Fra Angelico's painting and my tearful response. The image carried some mystery within my soul that I resonated with but could not own. Revisiting the painting, I began to explore the figures trying through associations and amplifications to uncover fuller ancestral or archetypal meanings. Like dream images the figures become symbols opening to another level of understanding; they unite what we know about ourselves and something unknown within our psyche. Viewing the **serpent, Mary, Eve, Virgin, dove** and **angel** in this way expands consciousness and can help us to personalize the images.

The Serpent

Let us begin with the serpent. In Fra Angelico's *Annunciation* we see Adam and Eve expelled from Paradise, the serpent having lured them into sin. Symbols can have many different meanings and this is particularly true of the serpent. It is both an earthy watery creature and a spiritual wisdom image. In the story of Grandmother Eve the serpent is a teacher of Wisdom. The wisdom of the Delphic oracle was spoken through the serpent priestess.[22] Serpents are symbols of immortality, renewing by shedding their skin. Viewed psychologically, the serpent as a symbol of fertility can represent the collective unconscious. Jung thought that snake dreams often indicated a straying from our instinctual roots. Thus the serpent is related to body and to healing.

I first came in touch with the meaning of the serpent as healer while I was a student in Zürich. A friend and I decided to take a tour of the ancient Greek centers of healing, among them Kos, Epidarus and Delphi. We had no intention of person-

22 Barbara G. Walker, *Woman's Dictionary of Symbols and Sacred Objects*, p. 387.

ally exploring images of gods or goddesses. Rather, we felt that as future psychoanalysts we wanted to visit these sacred places of healing where people had come for physical and spiritual therapy. For the Greeks, re-connection with the gods and a re-alization of one's religious "roots" were essential to healing. For this reason a temple occupied the central place in the area, located far out in the beautiful countryside. One of the most fa-mous of these sacred places is Epidarus, the shrine of the heal-ing god Asklepios, whose symbol is the serpent. His emblem of intertwined snakes, the caduceus, is depicted today in many pharmacies and medical centers.

Those who came for healing were invited to sleep in the holi-est part of the temple, the sanctuary. The word "incubare," in-cubation, means "sleeping in the sanctuary." Another word for sanctuary is "womb." Healing, it was believed, requires "incu-bation" or going back to the darkness of the womb for rebirth. The Greeks believed in the importance of dreams for healing. And before the patient was admitted into the sanctuary, he or she was asked to pray for a dream that might show the way to-ward wholeness. When the person had gone through the initia-tion and met the inner "ground" of existence, the inner God... she was called "religiosus," the one who gives attention to what is most important in life.[23] Parallels between the present day practice of Jungian psychotherapy and the initiation ordeal practiced at these Greek shrines thousands of years ago were obvious to my friend, Mary Lynn and me. The gods were very much part of the healing.

The serpent as healing power and creative presence goes back further than the Greeks to the Neolithic goddess often imaged holding a serpent. In some Sumerian creation mythol-ogy, all life begins with a serpent. The Serpent Goddess or Great Mother creates heaven and earth. As noted above, serpent sym-bolism ranges in meaning from poison and evil to healing and wisdom. The Genesis writer was well aware that it represented the ancient Goddess. As feminist historian Condren points out,

23 C.A. Meier, *Soul and Body: Essays on the Theories of C.G. Jung*, p. 139.

Genesis was written between the tenth and eight century BC when monotheism and the worship of a male God were being established.[24] Polytheism and the worship of the Mother God (represented by the Serpent) had to be crushed, as they were remnants of serpent worship noted in Biblical times. (Numbers 21:0; 2 Kings 18:4).[25] Thus, in Condren's view, the serpent in Genesis becomes an image of Satan, the evil one, the arch enemy of Yahweh.

As Mary Lynn later pointed out to me, the caduceus emblem also belonged to the Greek god Hermes (Mercury), the quixotic god of change or transformation. On his staff two intertwined serpents, one representing poison, the other, a healing balm pointed to the trickster quality of the god who could be ambivalent in his actions appearing, for example, in Paradise as demon and tempter. In *The Annunciation* by 16th century artist, Bartel Bruyn, the intertwined serpents appear atop Gabriel's wand suggesting that healing and transformation win out over darkness and sin.

This portrayal of the serpent as evil (in contrast to the former goddess relation to the serpent which was life-giving) has left a legacy destructive to both women and men. Rosemary Reuther shows how the Greek philosopher Aristotle and the Jewish philosopher Philo (first century AD) influenced later thinking. Both equated the spiritual principle or mind with the male and the material or instinctual realm with the female. Of course, as she points out, men are also bodily and sexual! Yet natural life, the body and the whole instinctual realm symbolized by the serpent (and the Great Mother) weighed more heavily on women who were placed in a negative and inferior role.[26]

If a facsimile of the Adam and Eve symbols appeared in my dream, I might imagine the serpent as a positive force provok-

24 Mary Condren, *The Serpent and the Goddess: Women, Religion and Power in Celtic Ireland*, p. 11.

25 Ibid.

26 Rosemary R. Reuther, "Patristic Spirituality and the Experience of Women in the Church," in *Western Spirituality: Historical Roots, Ecumenical Routes*, p. 145. Matthew Fox, ed., See also Baring and Cashford, *The Myth of the Goddess*, p. 614.

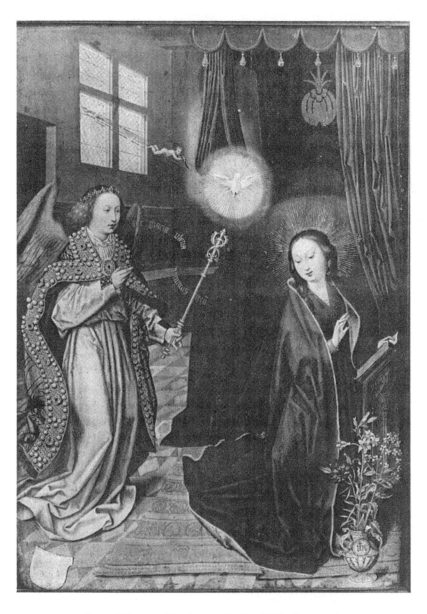

Bartel Bruyn. *The Annunciation* (16th Century).

ing me to risk disobeying some collective rules that stifle my life and spirit. In this spirit I feel called on to slough off worn out attitudes, ideas, beliefs or images of God no longer vibrant so that I can hold on to that which gives life and possibility for growth. Otherwise belief takes the place of personal creativity. I like to imagine Eve startled and fearful at the approach of the serpent. She enters into dialogue explaining why she should not eat of the forbidden fruit. The serpent urges. She answers, "Yes" and hastens to awaken Adam who eats. And they do not suffer death as Yahweh predicted. They suffer the wrenching experience of departure into the unknown, a birth. In the Annunciation, Mary also ventures into the unknown. Psychologically, Mary and Eve share common ground.

Mary and Eve

Mary and Eve have been viewed as shadow opposites, the dark and the light, the instinctual and the spiritual. The Medieval mystic Hildegaard of Bingen imagined Mary and Eve as One. In her view the Incarnation would have happened regardless of Eve's disobedience. Mary and Eve are "cosmic Theophanies" of the feminine whose purpose is to manifest God in the world.[27] In numerous Gnostic writings Eve is called the Mother of all the Living, the Provoker, the One who risked a "yes" to the serpent. Eve opens the way for each of us to develop awareness of what it is to be human. She explores and her curiosity leads to greater consciousness. Eve's "yes" to the serpent and Mary's "yes" to the angel represent two aspects of the journey toward wholeness.

Many women are accepting Eve-Mary as expressions of the whole feminine. A number of years ago feminist historian Barbara Grizzuti Harrison wrote:

> Mary had never been central to my worship. I have been inordinately fond of Eve; it was she, my comprehensible sister, who had planted in my blood and bones and flesh a vari-

27 Cunneen, *In Search of Mary*, p. 164.

able human love, the intoxication of the body. Eve's fall from
grace—her radical curiosity—set in motion the wheels of sal-
vation.[28]

Symbolically if we can see Mary and Eve as two aspects of one
woman, we are coming to a sense of who we are as women.
Harrison says that Eve opened the way to salvation through
her curiosity, her longing for "more," and her courage to take
risks to achieve it. This "set in motion the wheels of salvation."
Salvation means healing, getting rid of what stands in the way
of our becoming fully human.

In his *Annunciation* Fra Angelico offers an imaginative pic-
ture of how the Christian story of salvation began. It comes
through Mary. We see her at the right, arms folded across her
breast in a gesture of humility as she hears the message that,
though a virgin, she will bear a child named Jesus. Viewing the
Annunciation as poetic truth— as myth rather than logos—we
learn that the message of the new birth happens over and over
again. This is the paradox of myth which is an expression of
our deepest soul truth. Gertrud Mueller Nelson writes that her
five year old daughter when interviewed for entering kinder-
garten was asked whether her parents read her stories. "Oh yes,
my papa tells us Piggle-Wiggle stories and my mother reads
us Greek myths." "Really?" responded the interviewer. "What
are myths?" "Oh", the child answered after a pause, "They are
stories that aren't true on the outside. But they *are* true on the
inside!"[29] Certainly a good enough definition.

Myth clothes a mystery so profound that we respond with our
gut and heart, not with our head. At Christmas time who has
not experienced standing before the nativity scene the stirring
possibility of a new birth within, a fresh start? Like the winter
solstice arriving each year and like the Christian liturgical sea-
son, we experience the cyclical rhythm of soul time. In this time
rebirth comes through the Virgin *now*.[30] To understand how the

28 Barbara G. Harrison, "My Eve, My Mary," *Newsweek*, August 25,
 1997, p. 56.
29 Gertrud M. Nelson, *Here All Dwell Free: Stories to Heal the Wounded
 Feminine*, p. 20.
30 Campbell, *The Mythic Image*, p. 58.

words "virgin" and "virgin birth" were used in a mythic sense, it is helpful to go back in time when people had a greater feeling for the symbolic meanings attached to the words.

Virgin

For example, the original meaning of "Virgin" was "Womb" or "Matrix," and applied to the ancient Virgin Mother Goddess. It was believed that the world came into being from the source of her inexhaustible fertility. The Virgin Goddess was worshipped as the Source of Life though she could also bring destruction. One of these goddesses, Hathor, was worshipped in Egypt around 1300 BC. She was called the Goddess of fertilizing energy who gave birth to the sun and the earth, but she was feared for bringing the burning heat of summer, draught and death.[31] Of the numerous examples of the Mother Goddess giving birth to the world, one of the oldest dating to 3000 BC is the great Indian Goddess Aditi. She contained the god of Fire in her womb as well as all creation. All owed their life to her.

The much loved Sumerian and Babylonian Goddesses Inanna and Ishtar (4000 BC) were called Virgin because they personified inexhaustible fecundity and regenerative power. Sexual attraction on earth was the expression of this power. John Layard notes that the Egyptian Goddess Ishtar was constantly referred to as Virgin but she was not exclusively the wife of one god. In *The Virgin Archetype* he writes that Virgin means "pregnancy of nature, free and uncontrolled."[32] The Earth Mothers love with a boundless creativity and more often than not, sexuality is an expression of that love.

It is helpful to note that in the ancient world both those goddesses who bore children, like Isis, and those, like Athena, who did not, were called Virgin. It is this quality of self-possession

31 A. Harvey and A. Baring, *The Divine Feminine: Exploring the Feminine Face of God Throughout the World*, p. 41.
32 John Layard, *The Virgin Archetype*, p. 29.

that Mary Daly suggests as the positive meaning of virginity related to Mary as a model for women:

> A woman who is defined as virgin is not defined exclusively by her relationship with men...When this aspect of the symbol is sifted out of the patriarchal setting, then Virgin Mother can be heard to say something about female autonomy within the context of sexual and parental relationships. This is a message which, I believe, many women throughout the centuries of Christian culture have managed to take from the overtly sexist Marian doctrines.[33]

In Daly's view virginity refers to woman's independence and wholeness.

Past emphasis by the church on literal or physical virginity rather than on the mythic or symbolic meaning of virgin, "virgo," as "strong, one-in-herself," has offered nothing to many women who as mothers and caregivers have felt and continue to feel like second-class human beings. This exultation of physical virginity may go back to the Church's fear of women and sexuality, temple prostitution, and even to the story of Eve through whom all women became "temptresses."

Such a truth is the virgin birth. The angel tells Mary she will conceive by the Spirit. Such was the Buddha's conception. The Buddha's mother was considered virgin before and after his birth. One picture shows his mother, Queen Maya, the night she conceived the Savior.[34] She is lying on a mat dreaming that the form of a glorious white elephant circles her and strikes her right side with its trunk and enters her womb. She was considered a virgin before and after the birth. Another example of miraculous conception appears in an Egyptian legend. Isis, the Mother of Wisdom and Fertility, searches for her husband Osiris who has been murdered. Finding him, she weeps bitterly. As she embraces the corpse, she conceives her son, Horus.[35] To show that Virgin Birth is a psychic or spiritual reality it must be described as a miracle. It comes directly from God.

33 Mary Daly, *Beyond God the Father*, p. 84.
34 Campbell, *The Mythic Image.*, p. 243.
35 Ibid, p. 23.

To a friend who said, "I don't believe in Virgin Birth anymore, do you?" I responded that I use a double lens here. I can move comfortably between accepting the story literally and poetically. On one level I enter into the story with a "willing suspension of disbelief." I say, "Why not?" Like millions I am captivated by the beauty of this story. On another level I experience its meaning personally. The poetic or mythic approach personalizes "virgin birth" as a deeply spiritual reality within the soul. The ancient Mother Goddess bearing a child without male involvement symbolized the strength of the female, creating out of her fertile depths, from the plenitude of her being. We have seen this in the female creation myths where the world comes into being through the great "Womb." But whether the Divine source is imaged as female, male, or a union of the two, the virgin birth comes from this Greater Source.

Feminist and historian Marina Warner notes that centuries ago "virgin birth" was a shorthand symbol commonly used to designate a man's divinity. "The virgin birth of heroes and sages was a widespread formula in the Hellenistic world: Pythagoras, Plato, and Alexander were all believed to be born of a woman by the power of a Holy Spirit."[36] But how does virgin birth happen in each of us as a psychic reality? It happens as we respond throughout life to what urges us to our fullest humanity. What is the Mary "part" within us? Mary could represent for a man his anima, his feeling side, the archetype of life, leading him to a deeper level of creativity, closer to the Self. And for woman, Mary as symbol represents the urge to follow her true identity, her heart, as she communes with the Feminine Self. A woman experiences this as the urge to connect with her innate creative God-like power. Thomas Merton calls the "virgin" part of us, the "pointe vierge," the point within us that can be shared with no human being. It is the place in us open to the pure glory of God.[37] It is the place where God is "born" in us and where we begin to discover and live out of our deepest center.

36 Marina Warner, *Alone of All Her Sex*, p. 35.
37 Thomas Merton, *Conjectures of a Guilty Bystander* (New York: Doubleday & Co., 1966), p. 142.

Son of God

Before moving on to a key symbol in the Annunciation story, the dove, let us look at the *title* given to Jesus by the angel. Mary's child will be called Son of God. Before I learned in Scripture class that Son of God is a title, I used to puzzle over it even imagining a literal Father God figure (with beard) in the sky sending his son through the clouds! Actually for a time during the Middle Ages artists depicting the Annunciation began to show the dove flying down from the Father on a light beam on which rode a well formed *tiny infant* (see Bartel Bruyn's *Annunciation*). Theologians at first wanted to emphasize that the infant Jesus was sent from heaven. But this was literalism gone awry and soon this motif was omitted through fear that the faithful would begin to doubt Jesus' true humanity, born of Mary.[38] I learned that the title, Son of God, has an Egyptian source.

In the Egyptian religion a messenger, an angel, is sent by the God Amun (meaning "Wind" or "The breath of God's Life") to announce to Iahmes that heaven has chosen her ("The one born from the moon") to bear the new king, God's son.[39] In Egyptian mythology the title Son of God is given to the Pharaoh when he ascends the throne. As a crown prince he is the son of an earthly father. As in Christianity there is no contradiction here between the Pharoah's divine origin and the genealogy of his earthly ancestors.

> The virgin is simply an expression of the fact that the Pharaoh can be conceived by nobody else but God. No one but God was involved in the Pharaoh's begetting...Thus the Pharaoh can even have older siblings...without this calling into question the virginity of the Divine consort...[40]

38 Gertrude Schiller, "The Annunciation of Mary" in *Iconography of Christian Art*, pp. 33-52) (see the *Annunciation* by the Master of the Retable Reges Catholicos (Spanish 15th Century) in M.H. de Young Memorial Museum, San Francisco, CA.)

39 Eugen Drewermann, *Discovering the God Child Within: A Spiritual Psychology of the Infancy of Jesus*, p. 56.

40 Brunner-Traut quoted in Drewermann, p. 61.

The title Son of God, then, referred to a leader, virgin born of God, who could bring harmony to the kingdom. The Pharaoh brings order out of chaos, holding the opposites together. In Christianity it is Christ who is proclaimed Son of God and "all things are to be reconciled through him." (Col 1:19)

In depth psychology bringing disparate parts together is a function of the Self as self-regulating center of the soul. We can imagine its energy helping us to transcend the contradictions and conflicts in our life so that we can be reconciled to ourselves through a unity coming from a higher source. It, the Self, can be considered the "organ of acceptance, *par excellence.*"[41] It helps us to accept what we like and dislike about ourselves. If the relation between our ego and the Self (psychic God-image) is damaged, it will show in a lack of self-acceptance. A sense of inferiority, lack of self-esteem or its opposite, psychic inflation, can gradually be brought into balance as we feel genuinely accepted by others and by a loving Son of God.

The Dove

In Christianity a key reconciling symbol is the Holy Spirit, the fertilizing power and transforming agent in the Annunciation. The bird (often a dove) as sacred symbol of Spirit goes back to a time when it was seen as a mysterious messenger from an invisible world. People in the Paleolithic Age believed that their goddess—imaged with a bird head or with wings—gave protection in the three realms: air, earth and water.[42] In Neolithic times the Bird Goddess brought the rains and dew. Folk stories of the stork bringing the baby echo the ancient Mother Goddess Stork bringing the rebirth of spring. In Bronze Age myths the Cosmic Egg from which the world is born was laid by the Cosmic Mother Bird.[43] In particular the dove was held as sacred

41 Edinger, *Ego and Archetype*, p. 40.
42 A. Baring and J. Cashford, *The Myth of the Goddess: Evolution of an Image*, p. 13.
43 Ibid., p. 14.

symbol of love becoming an emblem for the Greek love God-
dess Aphrodite and the Egyptian Goddess Isis as a sign of their
love and boundless fertility. In light of this tradition the Chris-
tian Spirit (dove) as a psychic reality images woman's coming
into awareness of her Source, her strength, her own feminine
core, and her creative power. (See Chapter Two.)

Psychologically speaking the dove suggests the Spirit as an
epiphany of woman's soul, as her "goddess" side, her innate
fertilizing potency. Recall that the idea of virgin birth comes
from a time when people saw no connection between sexual
intercourse and the bearing of children. Women were thought
to conceive by a transpersonal power. They were impregnated
by an animal or a bird or by the moon. In a matriarchal society
the source of life resides in the power of the woman to create.
Ann Raymo in her *Annunciation* captures this depth of creative
union in eye to eye contact between Mary (woman) and her
Spirit dove. For me, reimagining the Annunciation dove from
the perspective of its pagan (feminine) roots broadens and en-
riches my personal spirituality. The creative spirit inspires and
uplifts my soul with meaning and hope.

The Angel

If we trust our inner Spirit we are more likely to trust that the
angel's message to Mary has a vital connection to ourselves.
The angel announces to Mary her godliness; she is "Favored of
God." Our angel comes to remind us of the majesty inherent in
being human. The angel protects and accompanies us in this
venture toward our fulfillment. The childhood prayer taught
years ago in many Catholic schools is still relevant and I am
amazed that it comes back to me. "Angel of God, my guardian
dear to whom God's love commits me here, ever this day be at
my side, to light and guard, to rule and guide, Amen." Our an-
gel is always present, its luminosity felt especially when we lose

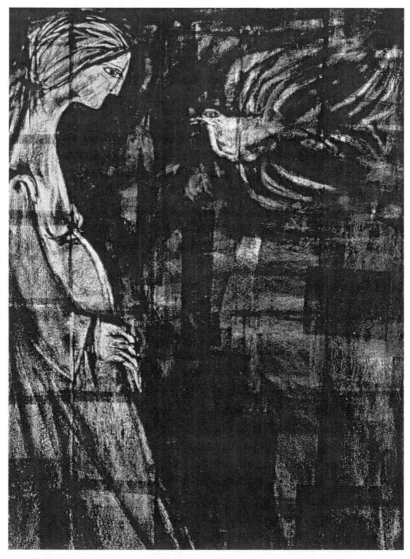

Ann Raymo. *Annunciation,* c.1960 (charcoal on paper).

our psychic balance or when we need a "push" toward living more intensely and authentically.

Angels are mediators, coming from the invisible realms beyond space and time. Jung sees angels as bearers of unconscious contents that want to become conscious. They remind us of the Greek "daemon," the inner guide who nudges us at times and who protects our interests. Such is the role of the guardian angel. The angel's presence may lift our spirits, calling us to new endeavors. But angels have a double role, for they bring wounding as well as blessing.

In the book of Genesis Jacob wrestles through the night with a dark figure, resembling an angel, and barely saves his own life. Jacob's experience left him breathless and exhausted. Yet at dawn, after a night of struggle, he says to the angel, "I will not let you go unless you bless me."(Gen. 22:26) Jacob limped away from the struggle, wounded in the hip, yet strengthened in his own sense of self; this strengthening was the angel's blessing. It was won only through struggle.

I am reminded of an attractive young woman, a university student, who came to me for therapy. She had had many struggles in her young life, the most stressful living with her alcoholic mother. One of her most vivid memories was watching at the window to see if her mother would make it home safely. She worried that her mother would wreck the car. She hoped that someone would come with her, which was often the case, either driving or helping her to walk. One day this student, whom I will call Rita, brought a dream to our therapy session. In the dream she was fighting with a dark figure. It was exhausting and she was wounded. To my astonishment she took out her drawing of the hip bone saying that this is where, in the dream, she had been hurt. I asked her if she knew the story of Jacob from the Bible. She looked at me blankly.

Psychologically speaking the fight with an angel is a motif related to the fight with the dragon (see "Hymn of the Pearl" in Chapter Two) to attain the treasure. The treasure is oneself, one's confidence, one's ego. It pictures some measure of victory over our negative and self-defeating "demons" who whisper

words of discouragement. In *The Living Symbol,* Jungian analyst Gerhard Adler writes of one of his analysands who during a long analysis dreamed that she fought the dark angel. He interpreted it to mean that she had won a stronger ego. But there was a step in her transformation when fight would give way to surrender. For, having been strengthened, she did not need to hold on to her ego but could open herself to receive or "conceive" the cosmic vision.[44]

The cosmic vision here refers to the Self, the Greater Power. If "vocation" is our call to wholeness, to our full personality, then the angel as agent is a messenger appearing at each stage of the way often with dreams, fantasies, and "pictures" of ourselves from the unconscious. Both in my personal journey and as a therapist I have listened to many of these messages, mysterious yet life giving, at times painful to accept (See my stone dream in Chapter Five.) The messenger appears, yet it is we who answer yes or no to the message.

Mary's Answer

Mary's "yes" or "Fiat" to God came not from passive weakness or fear of authoritative power. It speaks rather of her own power experienced when the barriers were momentarily dissolved in her union with God. But surrender, dependence and vulnerability are not popular words in a world that honors domination and control. "How can the liberation of women coexist with *any* form of submission—divine or otherwise?" asks feminist theologian Sarah Coakley, expressing an often asked question.[45] Coakley goes on, however, to say that it is in surrender to God in deep prayer that woman can find her *own* power. Elizabeth Johnson echoes this truth.

> As women articulate their insights about themselves and God change or conversion (is experienced) not as giving up oneself

44 Gerhard Adler, *The Living Symbol,* p. 225.
45 Sarah Coakley, *Powers and Submissions: Spirituality, Philosophy and Gender,* p xv.

but as tapping into the power of oneself (and this) simultaneously releases understanding of divine power not as dominating power-over but as the passionate ability to empower oneself and others.[46]

Mary's surrender is at once a dying and a birthing to her greater self. This is the paradox of losing and finding frequently found in the Gospel texts. The "yes" moment releases the flow between God and creature experienced as magical and mystical.

It is here that the Annunciation speaks to our own creativity in bringing God to birth over and over again. It is here that religion and depth psychology meet in an image whose meaning transcends both. Jung writes:

> To be sure, the thing for which Christ stands does not work for everybody, and nearly all my patients are people for whom the traditional symbols do not work, so our way has to be where creative character is present, where there is a process of growth which has the quality of revelation. Analysis should release an experience that grips us or falls upon us from above, an experience that has substance and body, such as those things occurred to the ancients. If I were going to symbolize it I would choose the Annunciation.[47]

Psychically, the Annunciation becomes a powerful image of our own self-realization, our "yes" to the joys and struggles of becoming who we are. If we miss this connection to its inner meaning, we are in danger of devaluing the mystery of our feminine soul and the God of our closest intimacy.

Was my tearful response to the Annunciation image a call to experience this inner meaning? *Yes.* Since I am not easily given to tears, I knew that the image held great psychic and religious importance. It resonated with something in my soul that wanted to become conscious. Revisiting the original painting gave me great joy. In identifying with the image, I found it a wondrously powerful "voice" speaking in language I could not fully comprehend. I have returned only once to Tuscany

46 Elizabeth Johnson, *She Who Is*, p. 67.
47 C.G. Jung, *Analytical Psychology Seminar*, Zürich (privately printed), 1925, p. 80.

to view Fra Angelico's masterpiece but I have returned many times to its inner treasures.

The greatest of these is awareness of the Feminine Self which opens to the God within. From this comes the realization that love is an energy flowing in me and in each of us, a creative spiritual force which unifies all of us as "Favored of God." In awakening to my emptiness and vulnerability, struggling with the dark side of the angel, I also awaken to my power to say "yes" to the present moment and "yes" to the unknown and unknowable future.

While Fra Angelico's Annunciation initially intrigued me, other artists' depictions of Mary's visit with the angel continue to evoke emotional response. Is it any wonder that the Annunciation is the subject of more Marian art than any other Biblical "scene" from her life? Each artist mediates the "call" of the gods residing within us, inviting us to greater consciousness of who we are, urging us to honor our creative spirit as bearers of the Divine. This motif threads through the next chapter in brief reflections on the Annunciation image as portrayed by other artists, from Dürer to Warhol.

Picturing the Annunciation

The Madonna painters saw high, high above her,
the eternal feminine prototype of the human soul.

—Emil Bock

Any divine power we may sense in a painting has much to do with ourselves. This is so because we put bits of ourselves into the picture. We approach the picture with our own "tinted" glasses. From an ageless source in the depth of our soul the picture speaks to us through our own experience. We may not be able to say why it is that we return to favorite images, but they resonate within us, consciously and unconsciously, both on an intellectual and non-rational level. And thus, befriending them, we begin to access their richness for us.

As I picked out a few of my favorite Annunciation images, I began to give them titles, placing them in a certain order, at first without a plan. But intuitively I began to recognize that the images spoke to me more personally than my just liking them. The first image, Annunciation as Call, speaks to me about vocation. And in the second, Tanner's angel of light celebrates an awakening moment, recalling personal awakening moments in prayer and in Jungian therapy. Annunciation at the Well, speaks to me of earth, the feminine, and thirst for the water of life. Her Spirit bird hovering over her, Poussin's Mary conceives as if creating through her feminine power. From the Spirit too, my creativity flows like a life line to hidden wells of energy. Annunciation as Night Vision speaks to me of Mary and her

"shadow" Eve, and my need, the need of all women and men to own all that we are.

The last three pictures bring me to more subterranean waters. Pondering the Annunciation and Death helps me to realize how my way of looking at death has changed over the years, from fear and apprehension to peace, even anticipation. Annunciation as Hope recalls the resilience of the human spirit and Annunciation as New Creation speaks to me about not clinging to old forms and images.

Psychic awakening, becoming more conscious of the divine power within, happens slowly; dreams and images play a part. Looking at religious pictures need not confine us to a traditional theology, as the exploration of Fra Angelico's *Annunciation* makes clear. Sometimes it is helpful just to rest in the image allowing it to unfold its message. At other times we can approach it more playfully, projecting into it, and, as in the following reflections we may begin wondering and wandering.

The Annunciation as Call

In Dürer's unusual Annunciation the messenger, after greeting Mary delivers a letter to her at the same time that the Father, represented by a heavenly beam of light, sends down the Spirit. Greeting, letter, and Spirit happen simultaneously and the Spirit dove looks as if it is about to land on Mary's head! Mary appears as a young woman dressed in simple head covering and full cut gown. She sits, clasping folds of her garment against her breast. She has no halo. Sturdily winged Gabriel in flowing robes greets her, "Hail favored one of God." And he extends the letter to her. She seems to gaze at it with restrained curiosity. Has she heard the greeting? Has she begun to read the letter? Has her body tensed with excitement or fear? Or does she wait, attentive to the moment's question, unaware that her answer will define her destiny.

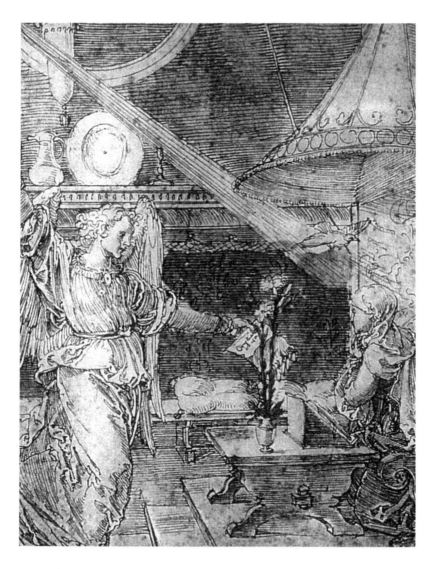

Albrecht Dürer. *Annunciation* (1526) Musée Condé, Chantilly.

The letter motif in this Annunciation has been related to a well known Gnostic tale, "The Hymn of the Pearl." In this story the prince receives a curious message. It appears first as a letter, but quickly changes form. Following is a brief summary of the Hymn:

> The prince leaves his Father's kingdom with provisions for a long journey to earth. His mission is to find the one Pearl that lay encircled by a serpent, in the middle of the sea. His royal parents take from him his robe of glory woven to conform exactly to his figure[48] assuring him that when he returns with the Pearl he will again wear the robe of glory. But after going immediately to find the serpent and the Pearl, the son finds himself distracted and begins to eat and drink with his new found friends on earth. He forgets about the Pearl and about his homeland. He goes to sleep. Grieved, his parents send him a letter exhorting him to remember why he was sent in the first place. The letter changes form. It changes into a bird and then into a voice. Guided by this voice he charms the serpent and recovers the Pearl. It is then that he returns home where his parents clothe him with his robe of glory and his royal mantle.[49]

A letter is a means of communication; here, a communication from another realm. It says in effect, "Remember your robe of glory." Or, in other words, "Remember who you *are*."

The heavenly mantle symbolizes the hero's genuine self rooting in his royal parentage. In forgetting his parentage he forgets his great worth, his dignity. While the complex symbolism of this tale does not concern us here, it is helpful to note that the letter recalls something vaguely known but forgotten. One might imagine the Pearl as symbol of the soul, linking the son to his royal home. In the Biblical Annunciation scene the angel first greets Mary. "Hail, favored one of God" reminding her, in case she was not fully aware, of her value. ("Hail" was an expression of greeting reserved only for high dignitaries, e.g. "Hail Caesar.")

48 Edinger, *Ego and Archetype,* p. 119.
49 Ibid., p. 120. For detailed analysis of the "Hymn" see Hans Jonas, *The Gnostic Religion,* 1958, p. 113ff.

In Dürer's Annunciation both the angel's greeting and the letter seem like voices awakening Mary to recognize her new status in the eyes of God. Kathleen Norris quotes a Benedictine friend, who, when preaching to his congregation on the Annunciation, said, "The first thing Gabriel does when he encounters Mary is to give her a new name, 'Most favored one.' It's a naming ceremony."[50] There are deeper roots to our naming—roots reaching back to our beginnings.

The Gnostic tale reminds us that who we are is always in relation to where we come from, our Source. Years ago on a trip to Bali I sensed how deeply the people are rooted in their Hindu beliefs and rituals. I was particularly touched with their ritual related to a belief in the prenatal origin of the soul. The Balinese believed that the newborn baby could not be placed on the ground until the age of six months. Since the baby had come from the gods and the spirit world, it still carried these spiritual energies which must be respected.

Having recently descended from the home of the gods, the baby has been treated somewhat like a god since birth. The name for "great grandchild" is the same as the name for "great grandparent"—"kumpi." They are both close to heaven. Children who die before their milk teeth fall out are buried in a cemetery away from the adults—because they are still in a sense divine.[51]

At six months the baby is losing its god-like status and can celebrate its birthday on earth. The child is placed on the earth under a cock cage to represent the membrane in which it was born. Family, relatives and friends enjoy an elaborate festival with decorations, music and good food. Growing up, the child celebrates the date of his/her "oton," the official birthday. Often the Georgian calendar birth date is forgotten.

St. Augustine says that we are born with knowledge of our origin, "morning knowledge." But as we grow older the knowledge fades. We forget... Augustine speculates that as we near

50 Kathleen Norris, "Annunciation," in *Watch for the Light: Readings for Advent and Christmas*, text for Nov. 30.
51 Fred and Margaret Eiseman, *Sekala & Niskala*, p. 1

death we recover this knowledge in a more conscious way, and with it, a sense of our life's meaning. This knowledge is with us from our beginning calling us forward into life, "reminding" us, at the same time of our origin. This calling, writes Jung, is "to be addressed by a voice," to have a vocation (Latin, "vocare").

In my Catholic upbringing "vocation" meant a call to the priesthood or the life of a nun or monk. These were deemed "superior" to the life of a married or single person. Fortunately today this view is no longer held. (See Chapter One on Virgin and virginity.) From early childhood I had an attraction to the religious life. This desire diminished through college and university years. For years I said "no" to that call and continued to enjoy traveling and socializing. My friends named me, "Auntie Mame," the name of the main character in a long-running Broadway play, because I loved partying. I took on this persona as I welcomed friends to a party, long cigarette holder in hand, with the greeting "Daaarling." But the "religious" call surfaced periodically as a "still small voice" within.

But for Jung the meaning of vocation is much broader than choosing a way of life, whether married or single, monk or nun. For him it is a call to become the person we are meant to be. He writes that each of us is called primarily to obey our own inner law, our deepest attraction or dream, for it is written in our heart. While vocation is primarily a call not to *do* something but to *be who we are,* that being is given form in our doing. If we are free and our creative gifts are loved into being, our doing *is the expression of who we are.* So it was with Dürer who dreamed of being an artist and whose father supported and encouraged him. So it is with millions of women and men who live their dream. And Mary? In the Biblical Annunciation story she is asked to become the Mother of Jesus. And she answers "yes."

Viewed symbolically the Annunciation tells us that we are "favored of God" and that we are called to bring forth the possibilities that lie within us, a symbolic "child." When our desires to express our gifts (our call) are thwarted, we and the universe are surely diminished. And yet in the twenty-first century, there are still too many women who have been called to fulfill their

deepest dreams, but whose gifts have gone unrecognized by the church, community, or sadly, even by themselves.

Annunciation as Awakening

Henry O. Tanner. *Annunciation* (1898) Philadelphia Museum of Art.

Through the centuries artists have often pictured the Annunciation Mary at prayer, the book open before her. At the angel's entrance she has appeared startled and fearful, or calm and serene. In Tanner's painting she seems bewildered by a sudden brightness, an angelic image appearing as a column of light. Still in her robe, her bed unmade, Mary, seems emotionally unmoved, momentarily dazed. Is she not quite awake? Or is it too early for her even to question? Is she feeling blue? Or is she experiencing and fearing the brilliance of her own unrecognized

spirit that wants awakening? Maybe she just does not know what "it" expects of her. The light is not something to fear, yet, she seems unsure that she wants to be fully awakened, maybe unsure that she is strong enough to bear the light, for there is darkness here too, and pain. Does Mary's pose in this painting represent a reaction that might be ours as well?

This picture invites me in. The warm earthy tones of the Middle Eastern room with its stone floor, its brown and deep red carpet and hangings, is aglow with a golden light, somehow not so otherworldly or distant as we may imagine angels to be. Mary is "warmed" by this light. It "becomes" her. Yet the light seems, at the same time, at least at first, foreign. Light and enlightenment are part of every day conversation. When we understand another's explanation of something, we say "Oh, I see." Or we say, "Can you enlighten me on that subject?" It was usual for nuns coming out of an eight day silent retreat to be asked by others, "What was your light (insight)?" Psychologically speaking, light refers to consciousness, awakening to something new about ourselves. In this painting Mary, though unknowing, seems open to the light. As she becomes enlightened about who she is, the "otherworldly light" will seem not so foreign. For she "becomes" light; that is, she becomes conscious of her favoredness, her "divinity."

Maybe the artist imagined the angel of light speaking to Mary saying, "You are to bear the Light of the World." Even so, in a psychological sense, I imagine the Light Angel awakening each of us to the reality that we too are "bearers of light." In a book called *Humble and Awake: Coping with our Comatose Culture,* Thomas Casey, S.J. says wakefulness is about searching, searching within ourselves for our own truth, speaking truth with others. We become comatose, he writes, when we succumb to powers that seek to ruin our environment, when the power of greed and lust numb our feeling and we become "objects," who "use" each other.[52] Awakening out of psychological "coma" requires silence. In a society that over-stimulates with words it is

52 Thomas G. Casey, S.J. *Humble and Awake: Coping with our Comatose Culture,* pp 35-50.

difficult to find silence. Sometimes we fear it. We call it "dead" silence and want to fill it with sound. Silence helps us to follow our desire for God, to live with the paradox of light and darkness. It fosters awakening to both.

In the Christian liturgy during the second week of Advent we hear the call of John the Baptist to awaken. "You must wake up now...Our salvation is near...the night is almost over, it will be daylight soon." (Romans 13:11-14) What is this sleep from which we are to awaken? It could be the sleep of death, of ignorance, of drunkenness, of forgetting. Awakening can mean "sobering up," that is, coming to our senses. Remaining asleep may indicate lethargy, a desire to remain unconscious. We may react to the call to awaken as Jonah did when he was called to go to Nineveh to preach to the sinful people. "Not me, Lord, I cannot do that, I'm not able." Jonah needed more self knowledge. He soon found himself in the belly of the whale, in the unconscious. From this "sleep" he awakened to another call, and he went to Nineveh. Sleep can indicate fear or a sense of hopelessness.

Psychologically, we may regress into "sleep" when we are confronted with something in ourselves we would rather not face. As a young nun I heard these words from the director of novitiate, "Why don't you get off your high horse?" I was, in her words, "cocky." Since I was unaware of this attitude in myself, I dismissed it angrily. I was still "asleep." This woman saw my mask but not my fumbling insecure self. I desperately needed a place to settle down within, to discover what was there. We sometimes glibly call this "self-knowledge." It was only years later, in Jungian analysis, that I slowly saw the "light," discovering that hidden part of me, a vulnerable child. The call to awaken is a call to change, and we continue to resist change until we meet with a stronger power shaking us from our lethargy. The prince in the "Hymn of the Pearl" forgot why he had been sent to earth. When he heard the voice, he remembered his true royal self. To awaken is to remember.

In Tanner's *Annunciation* the angelic light startles Mary as it would certainly startle us. She sits silently. I wonder what is

happening in her. I wonder if she feels that what beckons her to awaken more fully comes not only from an outer but from an inner Source. How would she put the vision into words? She appears held in a stirring, if tentative, communion with the light. We know that Self realization comes slowly. And the way to this awareness brings together experiences of light and of darkness, never separate but only more or less intense in their union. Doesn't this play of light and darkness pattern our existence? Thus the angel as Light summons Mary not only to bliss in the joyful anticipation of the Child who would become the Christ, but to the darkness of unknowing and pain.

It was the Buddha who spoke so movingly about awakening as enlightenment. In some traditions it means breaking through the illusion of this world to experience our eternal "underpinnings." But when we are awakened to the eternal and, at the same time, become grounded in the sacred feminine of earth, that is, our bodies, then we are truly awakened. "After enlightenment, more laundry" goes a Zen saying. We live not as angels but as incarnations of spirit. We live in the present the union of what the Buddhist would call emptiness and form, and the Christian, body and soul.

Tanner's *Annunciation* images this union. There is no dove descending from above. The angelic light seems to move slowly along the bed's lower surface. Could Mary's awakening represent not only her gradual self and God awareness, but the subtle realization of a saving power already within her? A pre-Christian liturgical verse suggests that the "birth" comes through the feminine earth, through our body, our flesh, through every man and woman. "Drop down dew, you heavens, and let the *earth* bud forth a Savior." (Isaiah 45:8) It requires only our awakening to the light and honoring it within each of us.

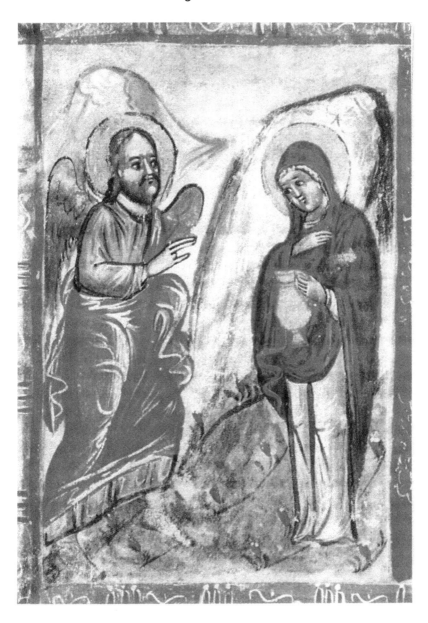

Armenian Manuscript 17th Century, *Annunciation* (Motif). British Museum, London.

Annunciation and the Water of Life

We cannot live without water. Our ancestors imaged the ocean as the Great Mother, which, like the moon, affected the rhythm of all life and from whose "Womb" all life emerged. As an embryo we lived in the watery vessel of our mother's womb. And our bodies carry watery depths within. If we have been wounded, our tears bring release and healing, unlocking the grip of our stony defenses. Water cleanses and renews; even the destructive power of water erases the old to allow new growth. The ancients believed that dipping or immersion in water gave protection from the evil spirits. Christians believe that through Baptism we become children of God. While water is elemental, on a spiritual level it becomes an agent of transformation.

In this 17th century Armenian manuscript Mary holds a water pitcher. This image is a variation on the Annunciation theme popular in early Byzantine art. Mary was often shown sitting in nature near a brook or a well. It is spring and flowers bloom along the grassy path. Maybe Mary is returning from the well. She stops short, startled when the angel approaches her, as if to say, "Who are you looking for.....me?" The intense red of her cloak contrasts with the light rock structures behind her. She drapes the cloak over her shoulders allowing her close fitting dress to show. In this Annunciation Mary holds the golden colored vessel near her body reminding us that in her womb the life giving waters enclose the Child who would teach about the living springs of life. A fatherly looking Gabriel seems hesitant as he extends his arm in greeting.

The inspiration for this image came from this charming account of the Annunciation from the Protevangelium 11:1-2 (based on Luke 1: 30-31):

> She took her pitcher and went out to fill it full of water, and behold, there came a voice saying, "Hail highly favored one! The Lord is with you; you are blessed among women." Mary looked about, to the right and to the left to see whence this voice might be coming to her. Filled with trembling she went into her house and putting down the pitcher, she took the

purple ... and sat down on a chair and drew out the purple thread. Behold an angel of the Lord stood before her saying, "Do not fear, Mary, for you have found favor before the Lord of all, and you will conceive by his Word.[53]

Western churchmen rejected such apocryphal accounts because they were not part of the official canon. Thus in the west we have few Annunciations showing Mary meeting the angel near the well.

Recently I stood at the ancient well in the crypt of Chartres Cathedral and, looking down I felt that if I fell in I would surely reach the underworld. Fairy tales and folklore tell us that the well leads down into the realm of the Earth Mother, and down into our soul. It is said that our ancestors, the Druids, used to worship a female divinity there. Today, close by this well that seems to reach the earth's core, a chapel houses the earthy, yet sublime black Madonna and Child, "sous la terre." The well at Chartres had been closed for many years during the nineteenth century, the tour guide told us. Could the closed up well reflect our own dryness?

Centuries ago, after the Crusades, the wasteland motif appeared in Europe. Some writers imagine that travelers, who had seen great dry and barren lands, were offered an explanation by Sufi mystics. The earth was dry and barren, they said, because people had forgotten to worship the Earth Mother, mistress of the rain.[54] Closer to our time, T.S. Eliot took up the wasteland motif:

> ...Here is no water but only rock
> Rock and no water and the sandy road
> The road winding above among the mountains
> Which are mountains of rock without water

53 Willis Barnstone, ed., *The Other Bible*, p. 385ff. Virgins making a veil for the Temple had been assigned lots to spin the thread: white, blue, scarlet and purple. The purple was assigned to Mary.

54 Barbara G. Walker, *The Woman's Dictionary of Symbols & Sacred Objects*, p. 356.

> If there were water we should stop and drink
> Amongst the rock one cannot stop or think.
> Sweat is dry and feet are in the sand
> If there were only water amongst the rock.[55]

The poet describes our cultural and spiritual draught. We thirst for the Divine Mother. We thirst for the water of life, one of her most powerful symbols.

Ancient wells were built over dry springs. Deep in the earth, researchers theorize, there are sacred pathways of energy and magnetic currents, "earth forces" emitted from moving waters.[56] Wells have been built over these "blind springs" where streams meet radiating energies. In ancient times these places like St. Non's Well in South Wales were sought out by women for childbirth. The old matriarchal religions honored these holy places and built cities and temples over them. Annunciation at the well recalls the age old feminine mystery of being reborn, feeling the juice and joy of living wholly.

Like the Greek Earth Mother, Demeter, often pictured at a well, Mary drawing water can remind us of our need to go downward to our inner "well," to the Source of Life. Within us as we attune ourselves to the earth's sacred energies, we find healing. Inspired by the Divine Feminine and by Mary, Jesus knew about this Source, experiencing it within himself. A spring of water will arise up within you, he told the Samaritan woman, quenching your deepest thirst. (John 4:14)

I love to sit near the water, an ocean or lake. When I am there, feelings stir and flow within me. I am calmed. How fitting it is, this "Annunciation by the Well." I imagine the angel coming to say, "Let go of your thoughts, your fantasies, even your fears and anxiety. Rest near the water, the Great Mother, and let your spirit conceive whatever wants to be 'born' in you."

55 T.S. Eliot, *Collected Poems*, p. 86.
56 B. Mor & M. Sjoo, *The Great Cosmic Mother: Rediscovering the Religion of the Earth*, pp. 124-126.

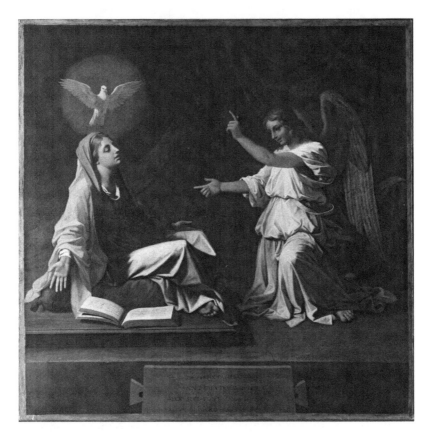

Nicolas Poussin. *Annunciation* (1656) National Gallery, London.

Annunciation and Creativity

In Poussin's *Annunciation* the dove hovers over Mary's head as she seems to fall into an ecstatic trance. It was the dove and its position which first attracted my attention in this painting. In contrast to many other Annunciations where the dove as Holy Spirit is flying down from God the Father, this dove takes a prominent position slightly above Mary's head. It seems to me more *her* dove than God's. The presence of the dove recalls the importance of bird symbolism during the age of the Great Goddesses from about 20,000 BC to 3500 BC. The dove had

been the companion of the goddess, a symbol of fertility and love. (See Chapter One.) Recalling the ancient goddess and her ever-present dove, Anne Baring and Jules Cashford write that in Christianity "it is assumed that the dove comes *to* Mary, whereas formerly, it would have been assumed to have come *from* her."[57]

The composition in this work is similar to Bernini's "Ecstasy of St. Teresa," an artistic rendering of Teresa's description of a vision. Obviously what is going on for both women is a penetrating encounter with God. But unlike Teresa, Mary has not been drawn up above her familiar surroundings. Instead, she sits on a wooden platform near the floor, reminiscent of the "Madonna of Humility," a cushion for her only comfort and support. Along with many other artists, Poussin shows Mary reading as the angel enters. The book is open, an indication that she is open to the great unknown, trusting in its wisdom. In this image the open book is "seconded" by the wings of the dove and her own arms extended wide as if to embrace the *new* though she knows not how it will appear through her. Mystically communing with her spirit dove, Mary falls into a posture of expectant repose. "Mary's opening out of her knees along with her hands makes the middle of her body, from breast to thighs, into a dark and open cave."[58] In this painting, drawn as we are to the dark center created by her posture, we sense Mary's openness to the life force and to pregnancy.

The pregnancy motif is central to Annunciation and, psychically, to all human creativity. For centuries it was believed that the Neolithic "bird goddess" was the creator who brought spring and the year's rebirth. Goddesses like Inanna, called the "Green One," and onward to our own day, Mary, are related metaphorically to the "dew come down from Heaven." In Greece the Earth Mother or Gaia, showered the rain and dew. Jungian analyst Patricia Berry writes that Gaia is the basic matrix and as Mother Earth also creates her own mate, Uranos:

57 Baring and Cashford, *Myth of the Goddess*, p. 595.
58 John Drury, *Painting the Word: Christian Pictures and their Meanings*,
 p. 59.

As this Uranos sky is a phallic force proceeding out of the earth, we can see it as earth's original hermaphroditism. Within the feminine as void, within her as passive lies a sky-like potentiality. Hence to get in touch with earth is also to connect with a sky that proceeds from earth. And the seeds that drop create a kind of original self-fertilization.[59]

The ancient images of the goddess and her dove as love emblem surely helped women to surrender to a greater Wisdom abiding in the depths of their soul. As Berry imagines, women sense this inner ground as they begin to open to their own "sky-like" potential. It is a mystical contact with a feminine aspect of God, one that frees our own creative juice.

Rollo May defines creativity as bringing something new to birth. What is brought into life, whether poem, pot, or nourishing dinner, is a reflection of Being because the insight, the energy within the creator conceiving the new comes from the Source of all Creation. Jung calls this the matrix or the realm of the Feminine. And the first step in discovering our creative potential is to be open to that mysterious realm, to risk following our "hunches," our feelings, our dreams.

Our openness to the angel's greeting is a risk. We do not know where it will lead. Our inner gestation draws us into our self where we mull over our intuition. We sit in silence as gradually our creative project begins to take form. It occupies our thought. Flashes of insight are written down quickly on scraps of paper. Sometimes upon awaking or while in the shower, the Great Feminine unconscious may provide a long sought connection. The insight comes through an energy that is not ours to master. We surrender to its flow. Like the "Fiat" of the Annunciation, "Let it Be," we bow to the One who knows us. For in our creative ventures we seek self/Self knowledge both for our own sake, and for the greater Incarnation of God in the world.

Men and women, all share in this energy, the unconscious Feminine Spirit. In the flow we design our creative work and imagine its effect. We nourish it and care for it. We must not

59 Patricia Berry, "What's the Matter with Mother?" in *Echo's Subtle Body: Contributions to an Archetypal Psychology*, p. 6.

minimize the hard labor required, giving form to the unknown: the periods of chaos and frustration, the inner voices of doom, ("That's not very good!") and, as well, that flicker of "Ahhh" as the work begins to "live." Neither should we close our eyes to the effects of this fiery energy when it is experienced as alien. Then the force can "speak" through us in symbols and images beyond our understanding. And, as we know, some artists have experienced the psychic turmoil and the pull into the dark void.[60]

Within the many facets and forces of the creative urge is what draws each of us to "be." I remember Elly Hillesum saying somewhere that one does not have to write or paint something to be an artist. It is the act of creating an *inner life* that is all important. It is this inner life or psychic pregnancy that women at times neglect. The wish to have a baby *may* mean that a woman wants to fill an inner need outwardly. Instead of developing her intuition into new ways of living her spirituality or into new psychological attitudes she may put her vitality into her physical childbearing.[61] Then her femininity is not lived psychologically and she may feel lost and bored when her children are grown up. Such a woman may lose her connection to her soul energy and may waste her life in withdrawal or in unsatisfying activity. I have spoken to women who feel "blank" inside, who feel they have nothing to offer. I have experienced this "lack" in myself.

It takes courage to affirm one's being. In my work as Jungian analyst I seek out the healthy and living human spirit. So often it is crushed and still being victimized through injustice and violence, outer and inner. In a small way I walk as companion with those on the way to rediscovering themselves. Years ago a young woman brought to therapy a drawing of herself. It was simply lines drawn vertically and horizontally like a grid. She felt imprisoned she said. But a little bird perched in the inside upper corner of her picture suggested a fragile hope of release.

60 *The Spirit in Man, Art, and Literature*, CW, Vol. 15, p. 75 ff.
61 Ann Bedford Ulanov, *The Feminine in Jungian Psychology and in Christian Theology*, p. 179.

Another woman brought the following dream:

> I am in a mansion, a part of the college I attended. In a large
> foyer type space a huge bird flies from side to side hitting walls
> and ceiling in a futile attempt to free itself. I think the bird
> will hurt itself and am angry that such a beautiful creature
> is penned in. The bird is black with streaks of silver and gold.
> Someone says the bird belongs to Liz another student. I go to
> her and plead for the bird's release. She says the bird must
> stay in. I am angry.

Liz, the dreamer recalled, was a socialite who seemed to
forge her identity through conforming to the expectations of
"high society." The dreamer began to realize that her own his-
tory as "people pleaser" had confined a creative spirit seeking
freedom. Through the years she has begun to accept this "bird"
energy as part of herself. A professional musician, she still ex-
periences times of self-doubt, frustration and blocking. There
are moments, though, when she feels full of wonder, as if she
"becomes" the music. At such times her Spirit bird is free.

Annunciation as Night Vision

Many artists have imagined the Annunciation as a unique his-
torical event in a "here and now" setting. Others choose abstrac-
tion or surrealism to plumb its emotional depths. This work, one
of a few nocturnal Annunciations, suggests dark mysteries with
overtones of sexual intimacy, religious ecstasy, fertility and cre-
ation. Creation myths imagine Mother Night bringing forth the
world through a void of blackness.[62] Early theologians viewed
the Annunciation as the creation of a new world through the
"conceptio Domino." In this rather opulent painting a seed like
flame atop a single candle centers our attention on a work of
superb composition and exceptional imagination.

The scene exudes a sense of drama. The figures, angel, Mary
and cherubs, combine to create a rhythm with fluid, even erotic
energy. Mary is gowned in red. Facing the viewer, eyes downcast,

62 Walker, *Woman's Dictionary*, p. 347.

Annunciation (ca. 1523-40) attributed to Parmigianino. NY, Metropolitan Museum of Art.

she looks aristocratic, secure in her refined sensuality. Somehow I feel Eve lurking within this Mary; though in the early Christian tradition Eve would never be described as "refined."

In Western art, writes Sally Cunneen,

> Mary was almost never portrayed as a sexual being. She was always shown fully, often voluminously, clothed, except in scenes in which she awkwardly but decorously nursed her child. Eve, on the other hand, was frequently portrayed as naked and voluptuous...[63]

In this picture Mary has been reading by candlelight before a bronze lectern, and now rests, her right leg extending through the open lectern stand, her book open. The little angel, legs extended, plays on the bed behind her and holds back the velvet drape.

Parmigianino may have been influenced by the 15th century practice of parody and burlesque of serious religious images and doctrine. But it is more likely that in his "forthright and sensual style" he was interested in exploring the interface between secular and religious imagery.[64] As we seldom see an Annunciation Mary like Parmigianino's, so we do not see Gabriel resembling the Greek messenger god, Hermes, who hovering from flight, gracefully holds a lily over Mary's head. The notes from the Metropolitan Museum of Art where this painting is housed, suggest that the painting served as a model for the artist's cousin, Mazzola Bedoli, who was planning an altarpiece. In *his* Annunciation the angel's wings are further shortened and he wears sandals and a pearl studded belt—a true Hermes!

The Greeks named Hermes "angelos," and while all angels carry his name, the artistic images vary greatly. Energetically, Parmigianino's angel differs greatly from Fra Angelico's. What is this hermetic energy? What qualities did the Greeks see in their messenger god? And how might these expand or confirm our meanings of Annunciation? Hermes, the Greeks said, was quick as air, spirit in motion. That is why the gods used him so often as messenger. He had his shadow side too, mischievous,

63 Cunneen, *In Search of Mary*, p. 113.
64 David Franklin, *The Art of Parmigianino*, p. 16.

thieving, and sexual, attributes absent in Christian angelology except, perhaps, for Lucifer, the fallen angel of Light. Hermes, like his Roman version, Mercury, was elusive; he could not be captured in limited form, pinned down. He is the Greek God of transformations. He brings about change.

It is his spontaneity and openness to the new that bring him close to the Annunciation motif, the new birth. Psychologically speaking, Hermes comes with an unexpected message, a word that brings new possibility, new awareness, new attitudes, and new shifts in consciousness within those who receive him. Could it be that in this painting the artist suggests that the surrender to the Unknown in religious experience is not totally divorced from human sexuality? To see Mary portrayed as a sensual being suggests that whether we accept virginal conception and birth as literal or psychic (religious), it *is* sexual.

Years ago neither at home nor at school do I remember hearing about the beauty of sexuality and its relation to spirituality. In our household sexuality was just not discussed. I later learned that in this regard my Irish Catholic family was not an exception.

Early in the 20th century when Jung challenged Freud's concept of energy as *only* sexual, he described psychic energy as moving along a broad spectrum, at one end moving to the physical and at the other to the spiritual. Jungian analyst Ann Ulanov writes that the symbolic connection of the numinous with the feminine is sexual:

> It suggests that for the feminine the heights of the spiritual passion are never divorced from sexual passion. Religion, then, is not different from ordinary life but is rather intensification and deepening of it. Perhaps the reason that "woman" and "feminine" have traditionally connoted nature, earth, and sexuality, as if divorced from spirit, is because they have been seen from the viewpoint of the patriarchal head ego which introduces a separating duality between the flesh and the spirit.[65]

65 Ulanov, *The Feminine*, p. 187.

Yet Biblical texts like "The Song of Songs" use sexual imagery to describe the heights of mystical prayer. And poets and saints, from Rumi to Teresa, describe their union with God similarly. Still, women suffer from the age-old split between spirit and nature, Mary and Eve.

Psychologically speaking Mary and Eve are opposites, each the shadow of the other, just as spirit and nature, body and soul are one. If we are to become whole persons we need to be conscious of less developed aspects of our personality for they are "us" too. Shortly after going into analysis I saw in a dream an attractive woman walking along the Niederdorf, the old town of Zürich. She was wearing a very short skirt, sexually provocative top and, high heeled long slender boots. "Who is this woman?" asked my analyst. "I don't know her. She's a prostitute." "She's part of you, of course." "Yes, my opposite." I responded. The dream reminded me of the danger in trying to be too "spiritual," of seeing my nun "persona" as the whole me. It invited me to connect more with my feminine nature and my body. For starters that would mean getting massages, eating good food, taking time out for socializing, "hanging loose"—more passion for life, less for duty.

Well known is the early Christian portrayal of Eve as the temptress, one who, like Pandora, brought evils into the world. It is Eve who has carried the female aspects of sexuality, considered for centuries in the Church and the culture as inferior and evil. French scholar Jean Markale speculates that Mary emerges in Christianity as pure and virginal in sharp contrast to the pagan practices in the cult of the Goddess Cybele, a religion adopted by the Roman emperors in the first and second centuries AD. In the pagan cult prostitution was a liturgical or sacred act. Men came to the temple to mate with a temple prostitute, a priestess of the Goddess of Love. The belief was that having sex with the prostitute, he would be united to the divinity of the Goddess. Since the boundary between sacred and profane prostitution tended to waver from liturgical action to sexual orgy, it is understandable that the Church Fathers condemned

the practice.[66] But this condemnation was, at the same time, a condemnation of Goddess worship, of Eve in her role as Mother of Life, and of sexuality itself which the Church for centuries regarded as sinful or shameful.

While this development partially accounts for why Mary is seldom pictured in sensual pose, there is another. In the process of purging the sometimes orgiastic aspects of temple worship the Galli (priests of the Goddess Cybele) voluntarily castrated themselves as a sign of their total dedication to her. "This was a remarkable gesture in a society that extolled virility."[67] According to historian Jean Markale, this practice influenced the Church Fathers in their understanding of virginity or celibacy as expressions of *total* commitment to God. Thus, we have seen in art, Mary as Virgin portrayed as maternal and virginal but seldom as erotic.

This 16th century nocturnal painting of the Annunciation speaks to me about Mary in her full humanity. It speaks about every woman receiving and owning her feminine self: her body, and her sexuality, her creativity, her assertiveness, her mind, her anger, her aggression, and her tenderness. Because woman is human she must strive to live all that she is. Living fully she regards death as fruitful completion, a mysterious passage.

Annunciation and Death

The title of this Annunciation, "An Angel announces her Death to Mary," may surprise us. The work, tempera on wood, is by Duccio di Buoninsegna (1255-1319) and is housed in Siena. Except for a column of bright yellow on the wall behind the angel (marking the direction from which he entered), the room is painted in complementary shades of rose. An aged and frail Mary clothed in a black cape over a gold trimmed red gown, her hands extending outward in a gesture of acceptance, sits on

66 Jean Markale, *The Great Goddess: Reverence of the Divine Feminine from the Paleolithic to the Present*, p. 109.
67 Ibid.

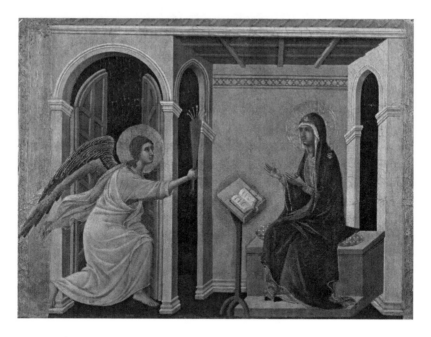

Duccio di Buoninsegna. *An Angel Announces her Death to Mary* (c.1308-1311).

a bench praying from her open book which rests on a simple wooden lectern. From the doorway and the arches no landscape catches our eye, no light of day. This is fitting since the angel announces that Mary will travel an inner night journey into darkness. The floor offers us no colorful decorative patterns. It is black. Symbolically black represents fertility and potential, endings and beginnings, the great unknown, or the dimly remembered. The angel presents Mary with a palm branch, symbol of Paradise.

The source for this work is an apocryphal account by Pseudo Melito describing how Mary remained in the care of John after Jesus' death. "In the twenty-second year after Jesus had conquered death and gone to heaven, Mary spent one day in a remote corner of her house weeping, inflamed by the wish to see the Redeemer again; behold an angel appeared to her in gleaming light, greeted her and said,

I greet you, blessed by the Lord...I bring you this palm branch from God's Paradise; let it be carried before your coffin, when in three days you will be transported to heaven in your body. For your Son awaits you with the angels and with all the Powers of heaven.[68]

The account goes on to say that Mary wished to have all the apostles gathered around her as she lay dying. And miraculously, the apostles appear. Mary tells them that in three days she will leave her body and asks them to stay with her and comfort her. In a short while Jesus appears and speaks, "Come, you chosen one, most precious pearl...for the heavenly hosts await you." As Mary breathes her last, the apostles pray and begin to plan the ritual for her burial. There is some disagreement about who will carry the palm branch before the coffin and finally Peter reminds John that Jesus had given Mary into his keeping. John, then, carries the palm.

The writer then describes the procession with John leading the group and Peter, Paul and the others singing hymns as they laid the body in a new tomb. Shortly afterwards Jesus appears, awakens Mary and leads her into heaven escorted by multitudes of angels. Reading this account in its simplicity and naiveté, I was reminded of my early days as a cloistered nun. When one of our sisters died, we would escort her coffin to her resting place, carrying candles and palm branches. An impressive scene it must have been to see our veiled figures making our way slowly up the path lined with pine trees, the sun shining through, lacing patterns on the ground. Strains of the hymn, "In Paradiseo" filled the air as we sang, "May the angels welcome you and accompany you into Paradise."

Such rituals dignify our life and our passing and they are repeated in one form or another every day. They console us and inspire hope. I have been thinking about death lately. It makes me want to savor every minute of life. One year, on a hot summer's night I sat on the porch with my eighty-seven year old neighbor. I listened as he talked about the many funerals he

68 C.H. Ebertshauser, H. Haag, J.H. Kirchberger, D. Solle, *Mary: Art, Culture, and Religion through the Ages*, p. 51.

and his wife had attended recently. "It's such a mystery, death. We don't know where we're going." "No," I responded, "But lately I feel myself becoming curious about that other side. I'm beginning to feel like it's a great adventure." "Well," he said smiling," I never heard anyone say *that* before."

For centuries our ancestors believed that at death the angels lead us to our eternal "ground" and we meet our original image as "dreamed" by God. In other words, we would know our self in our full god-like-ness. In knowing our glorified self we would know God. It was believed that as our body grows old, nature is busy incubating and strengthening our soul so that when our body dies our soul lives on its own. In the *Tibetan Book of the Dead* part of the initiation process after a person's death and before rebirth was to "restore to the soul the divinity it lost at birth."[69] Not lost, I feel. Maybe forgotten, but there all along.

The apocryphal story that inspired Duccio's *Annunciation* tells us that after Jesus' death Mary went into a corner and grieved for him, as we all grieve for our loved ones, longing for them. At my death I want to be awake and curious. I imagine Duccio's Annunciation angel telling Mary and each of us that death is a journey into a dark brightness, an unimagined world wide web, a new possibility. Whether announcing death or new life, endings or beginnings, the angel proclaims hope in the midst of diminishment and unknowing.

Annunciation and Hope

Salvador Dali's *Annunciation* looks as if an explosion has ripped through the room catapulting Mary from her prayer stand and swishing Gabriel to the ceiling. Dali was a member of the Surrealist school of painting. Surrealism emerged in the 1920's, a reaction to late Romanticism, influenced by Freud, Jung and the new science of psychoanalysis. Artists began to paint subjective

69 *Psychology and Religion*, CW, Vol. 11, p. 514, par. 842.

states of the soul: dreams and fantasies, our deepest desires and fears that exist beyond the rational.

In this drawing I wonder whether the artist was expressing the dynamite power of the Annunciation image itself. This was my first reaction to the work. Or was he showing that in a nuclear age we can destroy our spiritual treasures, our values, ourselves? Certainly fear, anxiety, and depression increased with the advent of the nuclear age, and Salvador Dali expressed these psychic states in many of his works.[70] In this *Annunciation* he expresses not only the effects of violence and destruction (which can be interpreted as inner as well as outer), but, more importantly, the ever present reality of hope.

In the midst of darkness, sadness, confusion, or even despair, we strive for light. We hope. Hope means that we *know* things will get better, though perhaps not in the way we envision. Annunciation enlarges our view. The angel's visit shakes up the "status quo" of Mary's daily life. In diverse ways our daily life is shaken by natural disaster, illness, and loss of faith. We are thrown into "impossible" situations. But we hold on. In the Biblical account of the Annunciation it is out of unknowing that understanding comes. And in Mary's question, "How shall this be done," the seeming darkness of the impossible, light emerges, and with it, the new.

As therapist I recall among my clients one in particular who had been hospitalized for serious depression. She said she wanted to die; she felt she was not a "person." She felt "not here," a "nothing." One day over the course of a long therapy, I offered her some sheets of black art paper and some colored crayons suggesting that she might want to play with "putting out there" something of what she was feeling. First came just jagged brown lines on the black; this gave way on some pages to a hint of earthy lighter brown and bits of yellow. Reds appeared later, tentatively. Two of the last "drawings" exploded with jagged reds and yellows in rather pleasing abstract design. The realization of self and of God happened very slowly in Monica with many turnings and seeming standstills.

70 Kenneth Wach, *Salvador Dali*, p. 15.

Salvador Dali. *The Annunciation* (1956) Salvador Dali Museum, St. Petersburg, Florida.

Numbed out emotionally, she gradually came to experience some of her anger, a catalyst in her becoming "a person." In the early days of our work together Monica said she could not pray; she was angry at God (good sign, I thought, this anger). Watching her through five years was watching someone "become" her own person. She had found a sense of her body and a deeper relationship with her God.

While I have never experienced clinical depression, I have in past years felt "dips" into the darkness hole. During one "dip" during my early fifties when I returned from Zürich, leaving behind friends and a "home," and moving into a new apartment, I felt my energy draining. It was pulling me into a bleak darkness, lulling me into a deep lethargy. One day I roused myself, walked to my bookcase and picked out a book on myth by

Mircea Eliade. There I read again about the cycle of death and rebirth, the myth of eternal return which is the underlying pattern of all creation stories. In the recurring seasons and within our soul it tells how from darkness, death, and winter bleakness, spring appears. The nature cycle "grounds" our hope. I read, I prayed words of straw. I waited. I hoped for this heaviness to lift me into peace, into energy for a new beginning.

Hope is a kind of relentless pursuit of resolution and freedom. The psychologist Karl Menninger wrote, "I would see in hope another aspect of the life instinct, the creative drive which wars against dissolution and destructiveness."[71] Hope is often symbolized as an anchor thrown into the deep to steady the ship. In the Bible and in fairy tales hope appears only at the *nadir,* the lowest point of despair. (Hebrews 6:18) Hope is activated then, through suffering and usually requires patient waiting. The Hebrew word for hope means "to wait."

Intact and clearly visible on the right side of Dali's *Annunciation* we see a faint outline of Gabriel still clutching a lily. Beneath him, and a hardly visible Mary, the prayer lectern and open book appear unharmed by the "explosion." The lily in mythology and classical symbolism represents the Goddess's power of self-fertilization.[72] The Roman Goddess Juno used her lily in this way when she conceived the god Mars, for all hero gods were born miraculously. Psychologically viewed we can imagine self-fertilization as the creative urge within us sparked and energized to bring forth our own work of art. Roman pagans said the lily came from Juno's milk. Christians said it came from Mary's. The lily then as feminine "cup" holds the essence of life like the chalice or the Grail. The lily is related to the spring Goddess Eostre, whose name gives us "Easter."[73] The Annunciation lily, then, represents fertility and hope, the possibility of new life.

71 Karl Menninger, "Hope," in *The American Journal of Psychiatry* (December, 1959), p. 483.
72 Walker, *Woman's Dictionary,* p. 426.
73 Ibid., p. 428.

And why, in Dali's *Annunciation*, hasn't the "explosion" destroyed Mary's prayer lectern and the open book? I find this an expression of belief that prayer and its power cannot be destroyed. Prayer anchors us in hope, enlarging the scope of our consciousness to know that even in our darkness and confusions a greater force brings good. Depth psychology might view prayer as the turning intentionally to helpful powers in the unconscious. Scientists speak of meditation as helpful in connecting us to right brain creative, non-rational "fluid" realms. In prayer we connect to our "roots" in the Feminine Source, the Self, center of our psyche which "desires" to become more conscious through us. My spiritual journey leads me into Mary's prayer, her "Yes" or "Fiat" to the angel's message, which brought a saving hope, a Child.

Annunciation and New Creation

When I first saw Andy Warhol's *Annunciation* (1984), I quickly turned the page as if the bright colors offended my sense of what an Annunciation should look like. But I found myself going back to that page and looking again and again. I was gripped by the same kind of experience that had drawn me to travel miles to view other more familiar Annunciations. Though I was vaguely reminded of one of those others, I felt compelled to just look at this unusual picture, and something deep within me stirred—a visceral response, perhaps to brilliant colors. I was puzzled by the absence of Mary and the angel.

In 1984 Warhol had made a series of religious prints called "Details of Renaissance Paintings." His Annunciation was based on one of Leonardo da Vinci's, painted in 1472. In Leonardo's painting Mary is seated regally at an elaborate lectern. The angel, with rather stiff, arched, and heavy wings kneels on the wide grassy lawn before her. Both figures blend in with the faded background of pale sky and dark poplars. At the center in the distance a mountain looms hardly visible in the mist. Warhol eliminates the figures of Mary and the angel including

Andy Warhol. *The Annunciation* (Leonardo da Vinci) 1984. Andy War-
hol Museum, Pittsburgh.

only their hands. Their figures disappear into the stage wings
while the audience views the landscape full front.

And what a landscape this is—mountain, trees and sky ex-
ploding in "pop" color! Not a cool blue "spirit" sky, Warhol
paints a flaming hot blood red heaven, as if to say, "The Spirit
fills the whole world!" This *Annunciation* excites, stirs emotion.
The artist shouts to us to see the Annunciation image afresh.
Far from manipulating Leonardo's image, Warhol enriches its
meaning by mediating that meaning to today's world. In this
rendering the focus is on the mountain, though if we look close-
ly, we see a city built near a port, its ships barely outlined. The
tall poplar trees like sentinels draw our attention downward
to the hands. Hands are symbols of power, or making, and of
connecting people with each other. We often "speak" with our
hands. Warhol's emphasis on the hands only accentuates the
"presence" of the unseen figures. The angel's hands both greet

Leonardo da Vinci. *Annunciation* (detail).

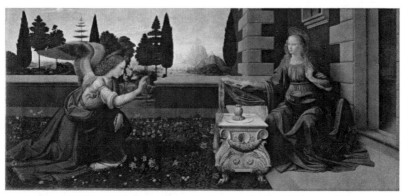

Leonardo da Vinci. *Annunciation* (1472) Uffizi Gallery, Florence.

and call and the virgin's fingers move toward her response. In terms of the Biblical story the essence of the encounter is expressed "in a kind of sign language."[74]

74 Jane Dillenberger, *The Religious Art of Andy Warhol*, p. 48.

The center of this picture is the mountain, in mauve, the color of wisdom. In all religions the mountain in its verticality and height symbolizes the center of the earth, the navel, where the first creation took place. Its function as place of security and protection is seen in the German "berg," (mountain, and "sich Bergen," taking refuge.)[75] In some traditions, the "belly" of the mountain was called an "oven," a womb, a place of transformation and rebirth. The mountain as symbol unites the opposites, masculine in its verticality and feminine as "womb." Appropriately in this work it takes center place messaging, as all nature does, fertility and new creation.

Warhol "lets go" of the traditional figures of Annunciation, the angel and Mary. Did he believe that the image and the message had grown sterile for many Christians? Did he resurrect a "dead" image, accessing its ever present energy? It seems to me that Andy Warhol acts like the mythical trickster, a devilish kind of figure who likes to mix things up, who tries to get us to see things in a new way. When life grows sterile, the trickster stirs the pot. The painting speaks of Spirit's fiery presence infusing nature and the human. No longer are religions major conduits of Spirit. For many, nature is the path to realize the inner God.

Is this Annunciation pointing to the inner reality of God's "birth" within us? Warhol did not talk about the meaning of his work. Most artists do not. Known mainly as the "Pope of Pop" and living a flamboyant life-style, Warhol was silent about his spirituality and religion. He attended Mass every Sunday at St. Vincent Ferrer church and made visits during the week but never went to communion or confession. The priest speculated about him and his many visits to the church saying, "Warhol was bonding with a God and a Christ above and beyond the church."[76] I imagine that his art became his Bread of Life (Eucharist) where he lived in deep communion with the Feminine Source of all Creation.

75 Erich Neumann, *The Great Mother*, p. 45.
76 Dillenberger, *The Religious Art*, p. 33.

Personally this *Annunciation* reminds me that my desire for a fuller experience of God has been fed by signs, images, ritual, and sacraments. But these are *means* not goals of Christian spirituality. My longing is for the Reality beyond these. St. Paul's words come to mind. Now we see in a glass darkly, then, we shall see face to face. Our longing is for the demise of images and sacrament, for we know in faith that they will give way to something greater. It is this reality that has become more present to me during my spiritual journey through meeting Mary in her images. It is the psychic message of Annunciation: our identity as "favored" and God as our natural "ground."

At the Annunciation Mary was transformed from maiden to mother. In the early centuries of Christianity churchmen attributed to her the mythic titles of the Great Mother in her supportive and nurturing qualities. They could not do otherwise since Mary is an archetypal vessel holding these energies. Psychically, we can only "see" some realities about our self when we are ready to take them in. It has taken me a long time to feel my need for a new language or way of perceiving God. On personal pilgrimages to a few of her shrines I found Black Madonnas intriguing. But my first love was a Cretan icon of Mother and Child. Through this inspiring icon I was being led back to the wellspring of my soul. It is to this discovery of Mary as Mother that we now turn.

Discovering Mother Mary

The experience of God which is never directly available is mediated, among other ways but primordially so, through the changing history of oneself.

—Elizabeth Johnson

As Mother of Jesus, Mary becomes the Divine Mother. Given to us as *our* mother she takes on a deeper dimension echoing the Great or Primordial Mother. Repeating St. Bernard's well known prayer, many of us still address her, "Remember O most gracious Virgin Mary, that never was it known that anyone who fled to thy protection, implored they help or sought thy intercession, was left unaided...." It was my attraction to Marian art that led me—very gradually—to approach Mary as Mother. Twenty years ago while traveling in Greece, I discovered the "Virgin of Tenderness." This icon, together with the dark Madonna of Einsiedeln reflected as two mirrors my own light and shadow. In 2004 I visited the shrine of the Black Virgin of Rocamadour in France, still drawn to her mysterious blackness. By that time I had resonated with Mary as Sorrowful Mother, who like Demeter draws us into the depths of human grief and lifts us again into the joys of recurring springtime.

During my years in Zürich, Mary Lynn and I, both students at the Jung Institute, took advantage of some vacation days and a strong dollar value to tour ancient healing sites in Greece. We learned that in the healing initiation often the god or the messenger came in a vision or symbol, for example, as a snake or a dog. "The cure, in effect, was given all the dignity of a rebirth, but it was brought about by contact with the Earth ele-

ment in its divine aspect."[77] This is why the Greek Earth Mother, Demeter, was always worshipped in the places of healing along with Asklepios, the healer god, son of the Father, Apollo. I was unaware then of how the "earth element, in its divine aspect" was already at work in my own psychic healing. It was significant that a few weeks before Mary Lynn and I left for Greece, I had fallen and badly sprained my foot. During our travels the discomfort was a constant reminder of my need to care for my body, to honor my bit of "earth." It meant that I had to move more slowly and it slowed my thoughts too, a blessed relief.

It was the magnificent view that took me out of my own concerns as the bus approached the temple at Delphi where mountains and expansive sky seemed to touch. Here our ancestors came to ask questions and receive counsel from the Oracle, the "voice" of the God. Because of my injured foot, I was unable to climb up the steep path to the top where the temple stood; instead, I sat on a large boulder soaking in the sun and the silence of this sacred place formerly dedicated to the Mother Goddess. It had been taken over by the Sun God, Apollo. I recalled the legend describing how he had killed the Python, the dragon, and replaced the goddess culture.[78] But a female priestess, Pythia, remained. Apollo appointed her to begin the ritual ceremony and she first prayed to the Earth Mother reminding all that She was "there" first.[79] As I sat taking in the view, I sensed that She was still there.

During the afternoon of our first day in Delphi, I hobbled along a path near the hotel that led into winding narrow streets lined with shops. Unlike the crowded shops in Athens, these were mostly empty, their windows displaying a few icons and "objets d'art." I stopped short at one of the windows, paused, and entered. There on the wall behind the glass counter hung

77 C.A. Meier, Soul and Body, p. 139.

78 Jean Markale, The Great Goddess: Reverence of the Divine Feminine from the Paleolithic to the Present, trans. by Jody Gladding, pp. 2-4. Markale finds this legend helpful in explaining the change from female to male dominated cultures. Christian iconography shows St. Michael and St. George killing the dragon.

79 Baring & Cashford, Myth of the Goddess, p. 305.

four or five old icons. I was especially attracted to two of them, an Annunciation and a Mother and Child image unlike any I had seen before. The shop keeper gently lifted both of them on to the counter. I asked whether they were antiques (which I knew I could not afford) and he answered, "No, but they are old." With excited heart I thanked him and said that I would return. At a quicker pace I limped back to the hotel for lunch with Mary Lynn and breathlessly told her of my find and of my indecision about which, if either, I would purchase.

"Imagine your life back home with the icon," she looked at me intently. "Then imagine yourself without it." I needed that push. Back I hobbled to the shop since our bus would be leaving shortly. I had decided on the Mother and Child icon. On my way back to Zürich I stopped in Athens at the Byzantine Museum to see if I could find the "original" of the icon I had purchased. I found a reference to a miraculous icon, "The Kardiotissa" by Angelos, (c.1600.) a Cretan painter.[80] This "Virgin of Tenderness" has provided a setting for reflection and meditation for me from that day to this.

Icon, Virgin of Tenderness

Why had the icon affected me so deeply? I look again at the image of Mother and Child. Mary holds the child close to her as it reaches up with outstretched arms around her neck, pressing against her cheek with tender affection. The Cretan painter uses vivid colors. The Virgin's cloak is dark red, the color of fire, blood and passion. The infant's pinafore top is red contrasting with a white tunic. His trousers cover only one leg, the other hanging down uncovered. Even though I knew little about icons, I knew I had discovered a treasure that expressed an inner longing.

But the child in its mother's embrace seems awkwardly placed. This bothered me when I returned to Zürich. Why didn't

80 Manolis Chatzidakis, *Byzantine Museum*, p. 31.

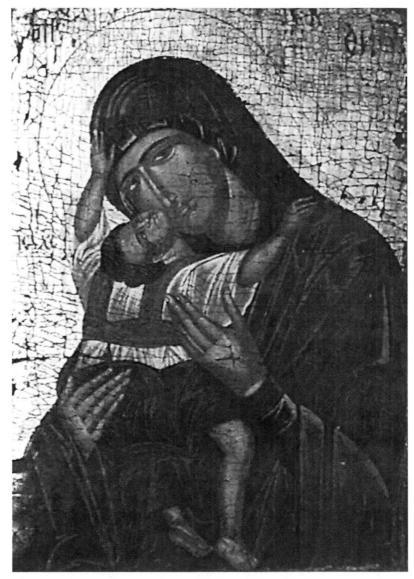

Copy of *Virgin of Tenderness* (c.1600).

the child look like a typical child? And there was something
else. In the icon painting the child's small head tops a pro-
portionately large torso. I discovered in my research that this
artistic stylization creates an abstract or otherworldly effect. For

though the artists at this time in history were able to add their own personal touches to their creation, still it was necessary to keep to the tradition that icons were meant to draw us into "another realm." They do. Just being "with" this icon in contemplative gaze, I have felt drawn into the image and through it into what feels like another spiritual dimension. In some sense the image became a mirror into which I projected something of myself and from which I was reflected. Symbolically mirrors fill a two fold need: the need for self and the need for God, two sides of the same coin.

Why is the mirror so important? Mirrors reflect us, not only our physical features but our inner life, our soul. The ancients were intrigued by mirrors, the earliest being pools of water. In the Greek myth Narcissus fell in love with his own image reflected in the water and thus he could not love the nymphs who pursued him. Some depth psychologists interpret this to mean, not that Narcissus was proud or full of himself, but quite the contrary, that he felt empty. Looking into the "mirror," he was searching for a self. This is not a far fetched notion. Psychologists tell us that to be human, to develop a sense of self, we need to see ourselves reflected in a mirror.

Our earliest mirror is our caregiver's face, usually our mother's, a human and responding mirror. Psychologist Donald Winnicott, who spent many years working as a pediatrician, writes that the baby, being seen or reflected in the face of the caregiver, begins to feel that it exists:

> What does the baby see when he or she looks at the mother's face? I am suggesting that, ordinarily, what the baby sees is himself or herself. In other words the mother is looking at the baby and what she looks like is related to what she sees there....[81]

Over a period of time with sufficient holding and love, the baby begins to feel real, to feel an "inner ground" or stability. For when the child's feelings are named, he or she feels less isolated. Someone understands. Winnicott used to say that receiv-

81 D. Winnicott quoted in Donald Kalsched, "Narcissism and the Search for Interiority," *Quadrant*, Vol. 13 (1980), no 2. p. 68.

ing "good enough" parenting, the child matures into a person capable of self reflection.

This self-reflection means that we are in touch with our soul. For centuries our ancestors believed that mirrors reflected the soul, that they were doorways to a spiritual realm. The Egyptians used the same word for "mirror" and for "life." Celtic women were buried with their personal mirrors which were said to be their soul-carriers.[82] Mirrors carried spiritual and religious significance. As human beings capable of self-reflection we can reflect to each other our gifts as well as our limitations. As living mirrors we can call forth *life* from each other as from a living spring which at times feels dry. One of the most touching accounts I have found describing such a "living mirror" is the story of Jeremy.

The story was told by a survivor of a concentration camp. This man, Jeremy, he writes, carried an almost numinous quality as he walked around the cramped quarters. He was an old Frenchman, joyful and strong, who arrived in Buchenwald in January of 1944. Jeremy was not startling; he was an ordinary teller of stories whose presence put people at ease. But he was more. "He was not frightening, he was not austere, he was not even eloquent. But he was there, and that was tangible."[83] When Jeremy would approach, the men tried to create a space for him as if to welcome him. They sensed him as a spiritual man. "Each time he appeared...I got a breath of life," one offered. Another said that when Jeremy looked at you, it was as if he "brought you back to yourself when you felt you were about to disappear."[84] Through Jeremy's presence many prisoners were freed to live and die with equanimity.

We need mirrors to be human, to bring us back to ourselves when we feel as if we might disappear. As Winnicott shows, this is what parents do from the beginning of their child's life. The baby looks up and sees itself in the face of mother or father.

82 Walker, *Woman's Dictionary*, p. 145.
83 Jacques Lusseyran, "Jeremy," in *Parabola Magazine*, Summer, Vol. XI, no 2. 1998, pp. 20-29.
84 Ibid.

And the baby feels. "From the look on your face, I know I'm wonderful and good." While later on our friends and loved ones function as mirrors, we need god-images to do the same. But our need for mirroring goes beyond this. The Psalmist cries out, "Show us, O Lord, your face, and we shall live," And again, "If the Lord hides his face from us, we shall perish." (Psalm. 43) These sentiments express the power of the God image to bring us back to our real self.

Since women generally have received little mirroring from society or church (nor often from their own families), they find increasingly a need for female God images. For centuries this lack has been keenly felt, if, even unconsciously (Mother Earth spirituality fills some of this need). What develops is an intense need for getting in touch with repressed emotion. In some women, the tendency is to block any show of this need, to take flight to the intellect and to academic pursuits; in others, the need is projected and the search for mothering figures continues often through life. I experienced my own mother as protective, caring, yet emotionally distant, wounded in her capacity to "draw me out," rather needing *me* as confidante. My father seemed withdrawn, "absent" even when present. Psychologically, the Mother icon stirred up in me early unmet needs for mirroring. I was drawn to its tender expression of Mary's love.[85] Gradually I began to imagine her not only as Mother of God but as Mother God, for at different times in our life, do we not fashion our gods as we need them to be?

I was amused when a friend hearing that I was writing about Mary asked, "You're not making her God, are you?" "No," I answered, "God is totally *beyond* image. Mary *opens* me to that 'Beyond.'" I could have added, "Since childhood I tried

85 C.G. Jung, *The Visions Seminars*, 1, p. 72 quoted in Ann & Barry Ulanov, *Primary Speech: A Psychology of Prayer*, p. 148. "When we say our God is love, we can be sure it is a compensation; we know it is not true. We say it to compensate the fact that we do not love enough, that we hate too much. Our ideal is love because we are too separated. People talk of community and relationship because they have none; they always talk of the things they do not possess...The way people define God is most characteristic."

to connect to a Father image; now I'm more comfortable with a Mother God." Today, increasingly, more women and men are searching for and finding personal images of God. Sometimes they find a place for their longing in other traditions, in works of art or in their dreams. Twenty years after my visit to Delphi, the icon, "Virgin of Tenderness," hangs in my study, a votive candle flickering light lines onto its darkened and now peeling surface. "Why don't you have that frame repainted and the gold touched up?" a friend offers. "No," I answer, "I like it the way it is: old, dark and peeling." I like to imagine it hanging in its earlier "home," a little church near Delphi. Mary, clothed in faded red, is framed in dark brown. There is a suggestion of the dark Madonna centuries old yet near and present.

I sometimes wish I had been a member of the Eastern branch of Christianity where icons have been venerated for centuries. The word "icon" means image and usually refers to a holy image. In the Eastern Orthodox Church icons have been venerated during the liturgy with prayer and chanting, a practice never taken over in the West. For many of the early Greek Fathers such as Basil, the icon was considered "equal in importance to the written word, the appeal to the eyes being just as authoritative as that to the ears."[86]

There is a tradition that when one looked at an icon one was in touch with a Presence, a miraculous and healing power. It was believed that the original image had come from heaven "untouched by human hands" so that any copy of the original had to be exact. This explains why many images were copied by mechanical means. There was no need, then, for the human artist. It was thought that the viewer had a direct line to the supernatural through the image.

In antiquity cult images were said to have come down from the sky. A wooden figure of Pallas Athena and the Artemis of Ephesus were referred to as "objects cast down from heaven by Zeus."[87] Cicero echoed this idea when he described an image of

86 Hans Belting, *Likeness and Presence: A History of the Image Before the Era of Art*, p. 70.
87 Ibid., p. 55.

Ceres, the Earth Goddess, as "not made by human hands, but fallen from heaven."[88] When St. Paul in the Acts of the Apostles objects to the image of Artemis at Ephesus, he says that it is made by human hands and thus cannot be divine. His opponents answered that the image had "come from heaven." I am always glad when I discover such information because it shows how our human longings are similar regardless of the god images that mediate them.

It is clear that both pagans and Christians sensed the heavenly origin of their divine images. I think that we echo this intuition when we say dream images come from the Dream Maker within who sends messages from another realm. Artists bring forth images from this realm. A Raphael Madonna, a dream "snake," a Kandinsky "Untitled" can lead the viewer whose soul resonates with the image into a Presence. But in the East, this Presence was so powerful that icons were considered invulnerable, having miraculous energy. They were carried in procession and were believed to give protection over inhabitants of whole towns. I am reminded of this belief when every year in my Italian neighborhood the statue of our Lady of Mt. Carmel is carried from the church in procession to thank her for her help and protection. At night the statue is carried back to the church in candlelight procession to the sound of fireworks.

Isn't it hard to believe that in Eastern Christianity (726-843 AD) a civil war was fought around the use of images? The Church feared that people would worship the icon itself as an idol, as it believed the pagans did, and not the religious reality represented. As we have seen, the "pagans" too reverenced their images as "made in heaven" or sent from beyond by Zeus. After the clash between those who wished to destroy icons and those who wanted to worship them, images were allowed in the churches. Numerous icons of the saints and of Jesus and Mary appeared.

In the Eastern Church icons of Mary appeared in both public and private devotion. Often the Virgin was pictured with her Child. She is sad-eyed as if sensing his future and death by

88 Ibid.

crucifixion. Often she looks away from the Child as if she is in another world. This stylistic device was used to draw the viewer into the supernatural world. Its restraint was replaced during

Black Madonna of Einsiedeln, Switzerland.

the tenth century by new images portraying human emotion and the human touch. The "Virgin of Tenderness" comes out of this tradition. It was as if I had felt "seen" by the Mother and was then drawn into a deeper sense of both self and God, the Female Face of God.

The Black Madonna

Another Madonna—a dark one—has become a powerful mirror image for many women. There is a long tradition in Christianity of the Black Madonna. She is black and beautiful, symbolizing the dark earth in its rich fertility. In the early 1980's I used to visit the Benedictine Abbey in the little town of Einsiedeln near Zürich. I loved to walk along the quiet hillside lined with images of Jesus' Way of the Cross. On big feasts like Christmas I gloried in the ritual, the organ music and the choir. On my first visit, as I entered the basilica and saw the Black Madonna, I was stunned. She did not so much attract as intrigue me. It was years later that I realized why. (See Chapter Five.)

In his book, *The Black Madonna,* Jungian analyst Fred Gustafson connects the Black Madonna with the Indian Kali and the Egyptian Isis.[89] These two goddesses are dark Mothers related to body, instinct, and earth. Kali is both nurturing and destructive, two sides of one cosmic rhythm. The Egyptian Isis, called the "Black One," was said to possess the elixir of life and was called The Great Mother of Life, Death, and Regeneration.[90] She represented the matrix, the earth, out of which comes new life. Like the goddess, the Black Madonna symbolizes the Wisdom of the earth and the gift of sexuality. In alchemical language the Black Madonna represents the first stage of personal psychic change, the "nigredo" or blackness. Applying this to ourselves we can say it refers to dark, hidden, repressed or undeveloped aspects of ourselves that want to be lived. Often

89 Fred Gustafson, *The Black Madonna*, p. 79.
90 Baring and Cashford, *Myth of the Goddess*, p. 225.

they remain hidden within us as if they were hidden in a dark cave.

In this journey to Mary and to self, the cave in its literal and symbolic meanings takes on special significance. The Black Madonna and her goddess ancestors know caves. Underground chambers were associated with the worship of the Black Goddess. And there is a tradition that the Virgin of Montserrat was discovered by shepherds in a cave where the people had hidden her during the Moorish invasions.[91] Feminist writer Caitlin Matthews wonders whether these statues were recovered and re-named Mary. The original Black Virgin of Chartres called "Notre Dame Sous Terre" (Our Lady beneath the Earth) was said to have come from a Druidic center for spirituality around the area of Chartres. The story goes that the statue was carved before the birth of Christ and was hidden with other pagan statues in a secret shrine. Eventually it was placed in the grotto of Chartres Cathedral. Apparently the clergy tried to discourage devotion to this Divine image. During the French Revolution it was burned in the cathedral square.

A similar incident was reported from a Sicilian village where a statue of Isis long hidden in a well was recovered by men who carried it to the Cathedral where it "held" the holy water font. After a century it was removed when the church was being renovated. Apparently when the people wrote to the Bishop about restoring the statue he responded by having it hacked to bits.[92] To this day the people mourn their beautiful statue of Isis. They still post pictures of it in their shops. It was the people, I feel, who were in touch with the deeper meaning of the Feminine expressed in the statue of Isis. They valued it both for its artis-

91 Caitlin Matthews, *Sophia: Goddess of Wisdom* (New York: HarperCollins, 1991), 195.

92 Theresa Maggio, *The Stone Boudoir: Travels through the Hidden Villages of Sicily*, pp. 72-73. China Galland recounts a similar story in the town of Enna, Sicily where for centuries in a tiny church statues of Demeter and her child held an honored place. No one seemed to notice that the child was female and that the mother was Demeter, not Mary. Not until the 19th century did the Pope have the statues removed to a museum. (See China Galland, *Longing for Darkness: Tara and the Black Madonna*, p. 359.)

tic beauty and because they were grateful to her for watching over their fields. They saw no conflict between their love for Isis and their love for Mary. Apparently through the ages images of both figures had been hidden for safe keeping.

Being hidden in a well or cave can express a situation today that applies both to women *and* to Mary, that is, a powerful Mary. Women know their personal stories of struggle and retreat. I am reminded of the ancient Japanese Goddess Amaterasu who retreated to a cave when the powerful god Susano tried to destroy her. The other gods and goddesses made a huge mirror and placed it on a tree outside the cave. They then danced and created a commotion. They wanted her to come out. When Amaterasu came close to the cave entrance she saw her reflection in the mirror. Gradually she came out of the cave and the others rejoiced. When this happened, the story goes, sunshine returned to the land.[93] Today, I feel, many women are holding up the mirror for Mary or their personal female Divinity to emerge.

As Amaterasu's mirror has become a symbol of women's re-emergence from forced retreat, so, in Christianity, we see the emergence of Mary imaged both, as Dark Madonna and as light. I feel that we can make a connection here between the hidden goddess, the hidden Mary and our hidden self. We need to rescue Mary from too narrow a vision of her reality. Mary is *more* than a symbol of the church, more than Jesus' Mother. She is an historical revelation of the Divine Feminine. As women come into their own today we sense Mary as a carrier of the energies of the Great Feminine expressed in holy traditions going back 25,000 years. On this level Mary can become a personal mirror image calling us out from our fear and anger into the radiance of our full humanity. As "Mirror of Justice," one of her traditional titles, she frees her sisters and all peoples from bondage.

China Galland in her remarkable book, *Longing for Darkness: Tara and the Black Madonna*, describes her search for healing and for a female god image. She had been alienated from

93 J. Piggott and P. Bedrick, *Japanese Mythology*, pp. 11, 19.

the Catholic Church and felt no connection to Mary whom she says felt remote. She was attracted to the Goddess Tara of Tibetan Buddhism and set out to explore this tradition. During her travels she heard a talk by the expert on early Christian Gnosticism, Gilles Quispel. Referring to the Black Madonna as the only living symbol left in Christianity, he spoke of the need for women and men to integrate within themselves the feminine values so lacking in society. He related Mary to the Gnostic traditions of Wisdom and the Holy Spirit, for the Spirit was portrayed as Mother and prayed to because she, too, was an image of God.[94]

After hearing this talk, Galland traveled to Europe to visit the Black Madonnas there. At Einsiedeln she studied the image from the viewpoint of depth psychology and anthropology. She began to see that her "longing for darkness" was a longing for wholeness. Certainly darkness can be and has been seen as something negative. This is the root of racism. But darkness suggests a much more positive reality. It symbolizes the unknown, the unconscious, and like the black earth, the source of vegetation and life. In the female Buddha, Tara, Galland had sought something that she eventually found in her own Western culture and in her Catholic tradition. While at one time she roamed the world, rootless, she writes, "I now find in Mary a taproot that reaches to the center of the earth and a root system that stretches around the globe."[95]

My desire to enter that center led me to one of the oldest and most famous Black Virgins. Taking the train south from Paris I arrived in five hours at a forlorn station—no mountain or monastery in sight—called Rocamadour. As I asked myself, "How do I get to the monastery?" a Frenchman coming off the train seemed to ask the same question. "I usually drive here; I live in Marseille," he offered as he approached. He made a phone call and within minutes a taxi appeared. Luckily for me we shared the ride. As the taxi circled a narrow mountain road, my companion pointed across the canyon, "There is your des-

94 China Galland, *Longing for Darkness,* p. 51.
95 Ibid., p. 161.

tination." I saw as if clinging to the rock the outlines of this
ancient monastery where thousands had come to pray to the

Black Virgin of Rocamadour. 12th century.

miraculous Black Virgin of Rocamadour. Even Henry Planta-
genet II is said to have come here to atone for the murder of
Thomas Becket.[96] I felt the excitement of discovering an ancient
treasure. But unlike the pilgrims of old, I approached the scene
riding in comfort.

Legend has it that the statue of this Black Madonna was na-
ively carved in the 12th century by a monk, St. Amadour, whose
body had been discovered here intact. Apparently this body had
been found near a chapel dedicated to the Virgin Mary. (Ama-
dour means "Servant of Mary.") Historian Jean Markale writes
that the worship of this Virgin goes beyond medieval times to
the ancient mother Goddess Sulevia or the Celtic Goddesses,
guardians of the sacred waters.[97] Here rituals were performed to
beg the Goddess for rain and fertility. Like many sites of pagan
worship this one became a place where pilgrims came to wor-
ship Mary; often they were en route to Spain and the shrine
of St. James Santiago de Compostela. I stood recalling that St.
Dominic and St. Bernard had walked on these stones. Numer-
ous pilgrims had climbed on their knees the 223 steps to reach
the chapel where the Madonna is housed. I took the elevator.

As I walked into the small dark chapel I looked above the
altar where the statue is enclosed in a glass casing. She ap-
pears in a form called "Sedes Sapientia" or Seat of Wisdom. She
holds her Child on her lap facing out to the world, the child
symbolizing a new wisdom, a new vision for the world. And
here Mary is the Creator, the Wisdom and, as such, she embod-
ies the Source of becoming. My thoughts were interrupted as a
group of visitors with guide entered. I left and headed for the
shop where I bought a wooden statue of the Black Virgin, this
slender, primitive looking, not particularly beautiful depiction.
Looking closely at her rather stern wearied face, I noted her
gentle smile.

Later in the chapel I sat quietly for awhile. This Madonna
more than some others, less starkly portrayed, reminded me

96 Jean Markale, *Cathedral of the Black Madonna: The Druids and the
 Mysteries of Chartres*, p. 174.
97 Ibid, p. 175.

again of the ancient alchemical symbolism. The color black is
the absence of color, pure potentiality. It recalls not only the
dark night or the dark phase of the moon where light hides but
the alchemical black as the "stuff" from which all is created.
As the alchemists worked in their laboratory (and within them-
selves) to create something golden out of the black "prima ma-
teria," so, symbolically, Mary as Black Madonna represents all
creation before it was created.[98] I began to feel Mary as the 'po-
tential,' always creating the new as Wisdom does. She seemed
to whisper, "I am your 'potentia.' You are always 'becoming.'"
I prayed that our whole human family would know the harmo-
ny and unity within our grasp. I imagined the Black Virgin of
Rocamadour offering hope for a renewed vision of humanity.

When I had visited the Black Madonna of Einsiedeln, Swit-
zerland in the early 80's, I asked how the statue of Mary was
blackened. I was told that over the years the candle smoke be-
gan to darken the image. This is one theory. Others say that the
statues are black because they were copied from ancient statues
of pagan goddesses brought back from the East. I like Galland's
insight. She believed that the Madonna is dark "from entering
lives on fire."[99] When the fire of our longing meets her, she en-
kindles the blaze. The Black Madonna as Mother shows us that
our darkness, our demons, our anger, even our depressions can
lead to depths in ourselves that can uncover light. In this way
she has helped me to accept myself, body and soul, my gifted-
ness and limitations. She embraces my darkness, rigidities and
anxieties. Like the "Virgin of Tenderness" she enters my life to
transform.

The Sorrowful Mother

I had never felt much attraction to the Sorrowing Mary until I
visited Sicily. Here the Holy Week festivities have as much to do
with Mary, it seems, as with Jesus. This is probably true since

98 Ibid., p. 195.
99 Quoted in Cunneen, *In Search of Mary,* p. 298.

in Sicily the Earth Goddess Demeter is very much present *in* Mary.

One senses that Demeter's journey to the depths of the earth in search of her child strongly parallels Mary's search and Mary's sorrow. Demeter was a fertility goddess, whose daughter Persephone had been abducted by Hades into the underworld. Psychologically speaking, her search for Persephone (daughter, meaning "sprout" or new form of the mother) can be viewed as a search for herself. Persephone is the "seed" dying into the earth and returning in the spring as the new shoot. The story and its vegetation imagery is about personal rebirth. And it echoes the stories of earlier goddesses like Inanna and Isis searching for their sons and/or lovers who have gone into the land of death. There is no question here that in Sicily Mary plays a unique role in the Easter Mysteries similar to Demeter in earlier times.

Mary is not often pictured going down into the netherworld, though some apocrypha stories (texts not included in the official canon) describe her descending into Hell to plead for the release of sinners. These are faint traces of the real similarities between Mary and the Greek Mother Demeter searching out the lost child. After Persephone's abduction, Demeter roams the earth in grief and rage and during this time famine covers the earth. In her suffering and grief, she pleads with Zeus to return her daughter and he agrees. When Persephone returns, famine and blight disappear, the earth blooms. Mary's suffering plumbed the depths as she watched Jesus' way of the cross and his death. "Christ's passion is narrated through the perspective of the Virgin and becomes the Virgin's passion."[100] Many believe that Mary's suffering equaled that of Jesus. Mary is the Adolarata, the Suffering One. Today in the town of Trapani where Christian, Greek and Arab worlds meet, an eighteen hour Easter procession celebrating these mysteries begins on Good Friday.

My niece Barbara and I had been staying in Erice, a village perched high above Trapani, the location of an ancient temple

100 Margaret Miles quoted in Cunneen, *In Search of Mary*, p. 192.

to Venus, Goddess of Love. We planned to leave before the fes-
tivities, but luckily were able to view the preparations housed in
the local church. Inside we viewed magnificent Stations of the
Cross which would be carried throughout the town. These are
life sized figures with wood base and what looks like cloth ma-
ché covering. The figures are placed on platforms decked with
multi-colored flower arrangements. In medieval times these sta-
tions or scenes, representing events leading up to the death of
Jesus, were carried by local guild members: bankers and farm-
ers, butchers and tanners. Today one can read on each platform
something of the history and the particular guild members who
participated. The tradition continues.

Slowly I walked around the church until I stopped short.
There on the left side of the altar stood a statue of Mary unlike
any I had seen. She was robed in black, a silver sword piercing
her heart, an image of her anguish at the loss of her child to the
dark underworld. Carried high on its platform of considerable
weight, the statue follows the long procession as the crowds cry
out Mary's lament, "Where is he?" (This cry echoes the earlier
Babylonian Mother Goddess Ishtar mourning the loss of Tam-
muz, her suffering son lover whose rising would bring fertility
to the land.) One can hear Demeter as well crying, "Where is
she?" It is the cry of a mother who has lost her child. Here pa-
gan and Christian ritual meet at a depth of human emotion
that blurs their differences.

Mary as Sorrowful Mother has touched my heart. She has
entered into that place of my personal suffering, that place that
generates mourning, healing and love. Mary Dolorata becomes
a model for every woman's suffering and loss. She is comforter
because we identify with her sorrow. Her suffering, like Deme-
ter's, is redeeming, for, as the Gospel affirms, she became the
mother of John and of the entire human race. (John19:26-27)
In a talk on the Feast of Mary's Nativity in September, 2004,
Pope Paul II quoting St. Irenaeus said that the Sorrowful Vir-
gin is in a sense "The cause of salvation for herself and for

Dormition de la Vierge, Chartres Cathedral.

the entire human race."[101] This early Christian writer echoes a belief held through the centuries that Mary like the great Earth Mothers of antiquity creates, "dies" and recreates the world. In

101 Irenaeus, Adversus Haereses, III, 22, 4. See also Rev. Judith Gentle, *Jesus Redeeming in Mary* based on the theology of Louis De Montfort.

so doing she images the value of our personal journey to self fulfillment through our suffering.

For the image of the Sorrowing Mother evokes a universal longing for rebirth, a cry of hope. How can we today resonate to this cry for the lost child? Daily we mourn the many children and adults "lost" through violence or illness. Psychologically viewed, consider adults who as children have been emotionally abandoned. Such a child has caring parents who provide for its material needs. But it has not received sufficient response to its emerging self expression. The "fit" between child and mother has not been good enough thus the child experiences estrangement, often well into adulthood. The "inner child" represents hope...a new vision, a new possibility. Its healing or "resurrection" happens through re-connection to God and its real self. Loss then is transformed by joy.

From the *Virgin of Tenderness* to the Black Madonnas of Rocamadour and Einsiedeln my journey through images of Mary has opened me to soul depths where I sense the imageless God. We are image making creatures and throughout our life our God images change. "Unless we are completely defended and isolated from our Source," writes, Ana-Maria Rizzuto, "the representation of God like any other, is reshaped, refined and retouched throughout life. With aging the question of the existence of God becomes a personal matter to be faced or avoided. For most people the occasion for deciding on the final representation of their God comes in contemplating their own impending death."[102] For most of my life my God images were personal: Friend, Lover, Father, and Jesus. Mary as Mother came later. Then followed Wisdom-Sophia. It was as if the Feminine Divine urged me to "descend" into my feminine nature, my true feeling and emotion, to the realm of the Mothers. In contemplating my death, perhaps I am sensing a rebirth.

In its many forms the myth of rebirth provides a model for self discovery and creation, for changing patterns destructive to self and to others. One story has it that in order to get in touch

102 Ana-Maria Rizzuto, *The Birth of the Living God: A Psychoanalytic Study*, p. 8.

with herself Wisdom Sophia had to separate from the rational spirit world to descend into the dark earth. "The sufferings that befell her took the form of various emotions—sadness, fear, bewilderment, confusion, longing: now she laughed and now she wept. From these affects...arose the entire created world."[103] It may be easier for us to imagine Mary ascending to the courts of heaven than to see her descending into the depths of grief. As Sorrowful One, she has done this. Her darkness and suffering is a vital part of her full humanity as it is of our own.

The 17th century mystic Angelus Silesius speaking of Wisdom Sophia, wrote:

> As once a Virgin fashioned the whole earth,
> So by a Virgin it shall have rebirth.[104]

These are a remarkable two lines. Our ancestors imaged the birth of the world through Wisdom Sophia, she who exists before all things. Are we experiencing the world's rebirth out of chaos and violence? That too will happen, but only through the Virgin, that is, through the recovery of our connection to soul, the feminine Self at the heart of our being.

Mary as Primordial Mother

Contemporary artist, Frederick Franck shows how the image of Mary searching for her child blends into the archetypal primordial Mother. Reading his play, "Inquest on a Crucifixion, A Passion Play," I felt that I was coming closer to what the Mary image means for me. In this piece, Franck picks up on the theme of "descent to the earth." In one scene Mary searches for her son. She has been told that he is raised. "Why can't I see him? Help me so at last I may find my child..."[105] Here Mary is not portrayed as the Mother of God. Rather she represents every-

103 *Alchemical Studies*, CW, Vol. 13, p. 335.
104 *Mysterium Coniunctionis*, CW, Vol. 14, n. p. 318.
105 Frederick Franck, *The Supreme Koan*, p. 146.

woman, and, at the same time, she is an image of ancient creative Wisdom.

In response to the chorus who cry, "Hail Mary, full of grace, the Lord is with thee…" Mary responds, "I am who I always was before I was Mary…emptied I am of Mary…older I am than Mary…older than earth…Am I the mother…of…the earth?"[106]

Throughout this play Franck's focus is the paradox of Mary's humanity and Divinity.

> It has been a long winter
> The long and bitter winter of my barrenness!
> Now spring has returned to the earth!
> Let this old olive tree bear fruit again, Lord!
> Again and again I must bear him:
> Eternally in every child I shall bear the Son of Man,
> The son of earth…
>
> And if they must kill him eternally,
> I shall give birth eternally.[107]

Here the image of Mary searching blends into the image of the archetypal primordial Mother. Here she represents the mythic Earth Mother who takes on humanity's suffering. (Some theologians feel that Mary's "Fiat" at the Annunciation and her suffering merit her being called co-redemptrix with Jesus.) At the same time, Mary is everywoman who is empowered from within to descend into her darkness to resurrect what was "lost" and to let it blossom into spring.

Echoes of this descent and rise from darkness are found in mythic stories of the Great Mother, the womb from whom all creation came to be. As the male function in creation became apparent the Mother Goddess was imaged as virgin and mother who took to herself a son lover or spouse. Though subservient to her, this son becomes a suffering god who descends into the darkness and death, is "lost" to the Mother. She, imaged in Mesopotamia as Ishtar, the sorrowful Mother, weeps for him and, as "light" descends into the darkness to overcome it, and

106 Franck, *The Supreme Koan*, p. 146
107 Ibid. pp. 146-47.

to release her son.[108] As they return to the light, fertility returns to the earth. Gradually the son begins to take over the Mother's power and, as we see in a Babylonian myth, Marduk, the son kills the Mother Goddess and creates the world out of her body. The Mother Goddess as Creatrix disappears.

In Christianity the Creator is male, the Logos. We are so accustomed to a male God that it seems strange for us to refer to God as Mother. Artist Meinrad Craighead is an exception. From childhood she saw Mary as a Mother God and later painted her own God mother images. "My Catholic heritage and environment have been like a beautiful river flowing over my subterranean foundation in God the Mother. The two movements are not in conflict, they simply water different layers of my soul."[109] On one level Mary is Mother of God; on another, she is Mother God.

From the early centuries of Christianity churchmen have been wary of Mary's power. Mary was to be venerated but never worshipped. A case in point was the conflict in the fourth century with a group of women called the Collyridians. This sect started when a group of women living in Thracis began to pray and hold services in honor of Mary.

They offered bread cakes to Mary as their ancestors had offered to the ancient Queen of Heaven. The Bishop, Epiphanius, who, most probably had not met with the women, condemned the group. Describing their activities he wrote:

> What happens is that certain women decorate a chair or square stool, spread out upon it a cloth, and on a certain day of the year put out bread and offer it in Mary's name. All partake of this bread.[110]

The practice angered the bishop who not only saw the ritual as resembling the worship of the Mother Goddess, but because he felt that these women were acting as priests. He wrote that no women, not even Mary, could function as priest. These women

108 Baring and Cashford, *Myth of the Goddess*, p. 145.
109 Meinrad Craighead, *the Mother's Songs: Images of God the Mother*, p. 1.
110 Cunneen, *In Search of Mary*, p. 118.

were to be silenced. They were not to honor the Queen of Heaven, the title given to the Hebrew goddess.

Eventually we know that Mary *was* honored as Queen, but the official ban exists on women becoming priests in the Catholic Church. I feel that rather than desiring to be priests, these women longed to honor a female Divinity. This soul longing cannot be silenced. The Queen of Heaven, known too as the "Moon Mother" continued to be honored by European women who made moon cakes which the French called *croissants* or crescents for their lunar celebrations.[111] We still celebrate birthdays with lighted "full moon" cakes, a reminder of a Greek custom celebrating the monthly birthday of Artemis, the Moon Goddess.[112]

It has taken me many years to become aware of the significance of the Feminine Divine. Today I can be comfortable with Mary as the carrier of the ancient goddess/god/godde energies. Great Marian art, traditional and contemporary has deepened that awareness. Jungian analysts Anne Baring and Jules Cashford write:

> In the Catholic faith the persistent call for Mary to have a place in the Christian story of the divine is…at one level a plea to reinstate the divine as immanent in human life and in the life of nature.[113]

Viewing Mary as Light or Dark Madonna, viewing ourselves as images of God, "Ave Maria," we come to a place where we feel accepted for who we are, true and valuable, in our joys and sorrows, reflections of and temples of the Divine.

For the millions who have experienced the numinous through icons of Mary or statues of the Madonna, these figures become symbols leading into the realm of the imageless. Through works of art we enter the primordial world which Jung calls the invisible roots of consciousness. It is a religious experience because it links us to our Source. All artists work from this realm, from the depths of the unknown, the unconscious, often

111 Walker, *Woman's Dictionary*, p. 345.
112 Ibid.
113 Baring and Cashford, *Myth of the Goddess*, p. 364.

imaged as the great Ocean, the great feminine source of fertility. From the prehistoric cave painters to the abstract artists of the 21st century, it is from these archetypal depths that they draw inspiration.

Another popular archetypal motif that Marian artists have explored, the temple, will be discussed in the next chapter. For centuries it was believed that at the moment of the Annunciation Mary conceived Christ. She became a temple, housing the Sacred within her body. Artists depicted Mary both as human and as cosmic temple, as Pregnant Virgin and as Wisdom. Imaged as temple, human or cosmic, she seems for many to reflect the fullness of God energy. Whether as Jewish maiden or as mythic Queen of Heaven she has been honored as Temple of God, that is, as "container" of the God. Through contemplating various artistic depictions of her I have come to see her as symbol of the Goddess Creatrix.

Imaging Mary as Temple

Oh Mary, you glowing, most green, verdant sprout...
You bring lush greenness once more to...
The shriveled and wilted of the world.
 —Hildegard of Bingen

My earliest experience of a temple was a huge tree in our back yard. I had to walk up steps to reach the tree which made it seem more like a temple. As a child I did not make this connection between "my" tree shelter and a temple. But I do feel that protected by its hanging branches, I felt God's presence. The word temple suggests a place marked off, where the god is present. From temple comes our word "contemplate." The temple as metaphor for tent or shelter is deeply rooted in our psyche, and I believe that children often feel the mystery within them. My mother had planted a strawberry patch near the tree. And occasionally my friend Dolores would join me for a little treat as we sat together, but mostly I sat there alone.

In his autobiography Jung recalls similar moments alone as he experienced them in his childhood. He talks about his No. 1 and No. 2 personalities. No. 1 was the schoolboy and its world of classes and study. But there existed a whole other realm when he was alone, where he experienced the peace of an "other," a personal God. As a youth he was not able to articulate this experience but later he wrote, "At such time I knew I was worthy of myself, that I was my true self...In my life, No. 2 has been of prime importance, and I have always tried to make

room for anything that wanted to come to me from within."[114]
Each of us, I feel, experiences something of this meeting of self
and God in childhood, an intimation of an inner temple.

Later in life I learned that a temple can take many forms: a
building, a mountain, a cosmos, or a person. Most important is
the sense of "sacred space." In 1994 when I visited Bali to expe-
rience how the Hindus there worshipped in their temples, I took
a room in a family compound. I learned that a festival in honor
of the moon would be celebrated that evening in the nearby
village temple. The gracious lady of the house lent me one of
her saris, wrapping it around me, for, as she said, without this
clothing, I would not gain entrance.

I was surprised to see that a village temple is usually not a
building but rather a space where people bring their offerings
of choice vegetables and fruits to the gods. These are placed
on a canopied table and offered to the priest who blesses both
gifts and worshippers, as beautiful music fills the air. For spe-
cial festivals the Balinese Hindus worship in temples on hills
or mountains like most of our ancestors did. In ancient times
the mountain itself was viewed as a temple. Here, it was felt,
our spirit reaches closest to God, for the mountain's axis joins
heaven and earth.

Traditional Jewish temples reflected this attention to the cen-
ter. In the Jewish temple a number of courtyards surrounded
the Holy of Holies. One outer yard was designated for non-Jews;
another was for women, and another for men. The court of
the priest, the Holy of Holies was entered by the priest once a
year on the Day of Atonement.[115] Inside the outer court was the
space representing the Garden of Eden, the created world, and
then the Holy of Holies which represented heaven. The latter
were separated by a veil. The high priest representing the Lord
entered the sanctuary to communicate heavenly blessings to
those on earth, the worshippers. It has been widely accepted in
Biblical studies that the Holy of Holies was the scene of rituals

114 C.G. Jung, *Memories, Dreams, Reflections*, p. 45.
115 Margaret Barker, *On Earth as it is in Heaven: Temple Symbolism in the New Testament*, p. 8.

celebrating the birth of the gods similar to other creation stories. This would provide context for accounts of the birth of the king. (Ps. 110 or Isaiah 9:6: "Unto us a child is born.")[116]

In Buddhism, as in many religious traditions, the sanctuary is associated with the feminine. In Buddhist temples the word "garbha" refers to the innermost sanctuary, the "womb." The sacred relics, like the egg, represent Life. "The power of this womb and its world egg is transferred through the sacred altar that stands over the "garbha"... and becomes a force for spiritual life and renewal."[117] In Catholic "temples" called churches, the sanctuary traditionally housed the main altar. Here the priest, robed in white, offers the sacrifice of the Mass, a renewal of Jesus' offering of himself to God the Father. In the "supper" that follows, commemorating the Last Supper, Jesus becomes present as food for the faithful in the Bread of Life, the Eucharist.

I began to see the sanctuary as holy place both as "womb," and as a place of offering, a place for transformation and re-birth. How ironic that for years, women were not permitted into the sanctuary space except to clean or to arrange the flowers! As a young nun one of my jobs was to prepare the priest's vestments for the Mass and to wash the small altar linens. I scraped wax from the candles and cleaned the floor and often arranged the flowers. It never occurred to me that the sanctuary carried the feminine meaning of "womb." Nor could I imagine (as I do now) that Catholic female priests might one day enter that place to prepare the Holy Meal for God's people, offering and transforming the bread and wine, outer symbols of the inner Divine.

Discovering the meaning of temple as person seemed natural as I was drawn to depictions of Mary as the sheltering Great Mother in two paintings by Piero della Francesca: the *Madonna del Parto* and the *Mater della Misericordia*. I then discovered a

116 Margaret Barker, *The Great High Priest: Temple Roots of Christian Liturgy*, p. 150.
117 John M. Lundquist, *The Temple: Meeting Place of Heaven and Earth*, p. 62.

towering figure, a seven foot sculpture by Frederick Franck, *The Original Face* and an earlier medieval sculpture, the *Vierge Ouvrante*. These suggested Mary as a cosmic temple, as Wisdom Sophia.

Madonna del Parto

The fresco "Madonna del Parto" ("The Pregnant Virgin") was discovered in a chapel of a little cemetery in the town of Monterchi during the latter half of the 15th century. The townspeople tell stories that the chapel is built over a well. And long before their time women came here to pray to the Mother Goddess for fertility or to give thanks for a safe delivery. Here again paganism and Christianity meet in a tradition that transcends both—awe at the mystery of carrying and birthing new life. As part of my pilgrimage I arrived in Monterchi by bus on a cool April afternoon. The driver directed me to a path leading up the hill. After a short walk finding my way along a narrow path branching into other narrow paths, I came to the museum. The "Madonna del Parto?" smiled the receptionist. She ushered me into the room that housed the masterpiece.

I stood in silence for long moments. I imagined the fresco in its original setting in the little cemetery chapel. It was said that the artist painted the picture in honor of his mother who was from Monterchi. Had she been buried near the chapel? Had the artist expressed the deepest of mythic faith mysteries around death and rebirth? What intrigued me was the story of the ancient well believed to have been near or beneath the chapel. Perhaps centuries ago close to where I now stood a fertility goddess was honored. And now those goddess energies seemed alive in this statuesque serene beauty before me.

In this painting Mary is life giver par excellence. She towers over the angels who graciously hold the tent curtain back allowing us to view her. These curtains may remind many of the traditional metal tabernacles in Catholic churches where

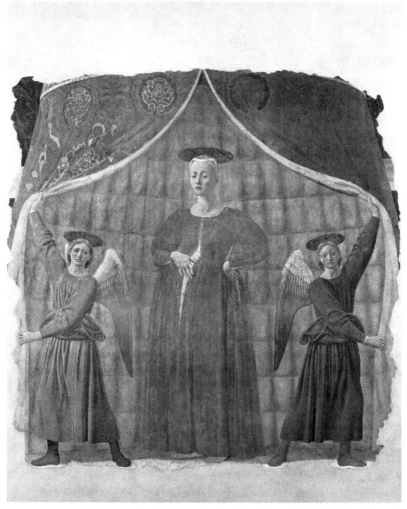

Piero della Francesca. *Madonna del Parto* (1460-65) Museo in Monter-chi, Italy.

curtains hid the Eucharist.[118] In this painting the pomegranates painted on the tent remind us of the ancient symbols of fertility. The Biblical name for pomegranate was "rimmon," to bear a child.[119] The fruit which means "apple of many seeds" refers to

118 Cunneen, *In Search of Mary*, p. 304
119 Walker, *Women's Dictionary*, p. 493.

the womb. Here Mary becomes the living tabernacle sheltering the Divine Presence.

Clothed in an opaque blue robe Mary wears the short veil of a married woman. Like all of Piero's Madonnas, she appears strong and self contained. She is a peasant woman yet with regal bearing, dignified. Mary knows who she is and is proud of bearing within her the Child. She points through the opening in her dress. She "seconds" the angels' movement in opening the canopy. She seems to invites us in. On entering this temple, we are silently drawn further inward to the mystery of Divine Birthing. Mary shares this mystery with us reminding us that we, too, are temples of the Holy Ghost and that the birth of God happens within each of us as well.

In some paintings of the Madonna we see the faint outline of a crown above her head. This crown motif is found in other paintings of the pregnant Madonnas. In medieval theology the crown placed over the Pregnant Virgin means that her role in the Incarnation made her physically incorruptible. Theologians asked, "How could the Mother of God die?" It was believed that through Mary's birthing of Jesus she gained access to heaven or to immortality. Through her role as Mother of God she became Queen of Heaven.

Mater Misericordia

The temple motif is suggested in another of Piero's paintings, the *Mater della Misericordia*. Here the Virgin, a queenly figure, spreads out her arms to provide a shelter for her devotees, and by implication, to embrace humanity. I was overcome by the sheer size of this Madonna. The artist portrays her as a superhuman figure; she towers over the people she embraces. *Madonna della Misericordia* is a work that touched people in the fifteenth century and still draws numerous visitors to the little town of Sansepolcro, Italy.

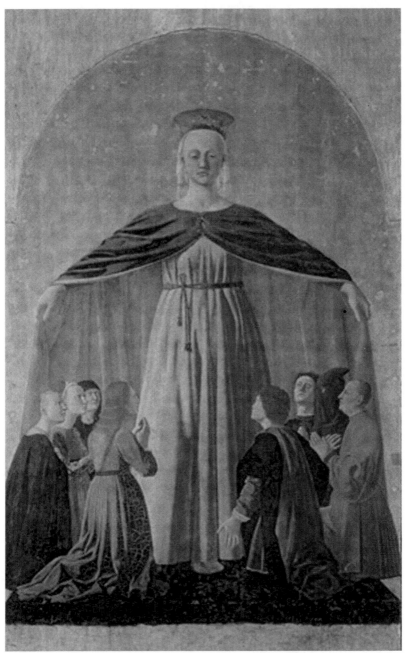

Piero della Francesca. Mater Misericordia (ca. 1460) Museo in Sanse-
polcro.

On an early spring day I took the bus from Arezzo. The bus descended into the valley that nestles Sansepolcro, and I was treated to a view of the shining Italian countryside. A few minutes walk through winding streets lined with shops and cafes and I stood in front of the town museum. I came upon the *Madonna della Misericordia* almost too quickly as I turned the corner from the entrance hall of this old building. There she stands, a powerful figure bigger than life, a superhuman Madonna taking under her outspread cloak those who ask for her help and protection. Feminist and psychoanalyst Julia Kristeva writes that the church did not approve of Piero's work because of its powerful female presence.[120] I began to doubt this later as I walked around Arezzo, where numerous representations of this image in fresco, sculpture, and painting grace the walls of many churches and museums.

Painted around the year 1454, Piero's Madonna was the central panel in an altarpiece commissioned by the Confraternity of Santa Maria Misericordia, a charitable organization given to prayer and compassionate care of the poor. The group founded hospitals, fed the hungry, visited the dying and paid funeral expenses for the poor. Visiting Arezzo again recently, I noted a sign which read "Office of Mater Misericordia." Here the poor still go for help. Records in the town of Sansepolcro show that Piero's family belonged to the Confraternity, explaining, perhaps, why he was commissioned to paint the altarpiece.[121]

This Madonna is well titled, "Misericordia." The root of the word is "core" or "heart." Like the mystical devotion to the Sacred Heart, it reveals the core or essence of life's meaning— love. In the painting this motif is expressed in Mary's gesture of reaching out. Mercy or compassion means "suffering with." It expresses movement toward and responding to others' misery. Here we see a relation to the ancient Chinese Goddess, Quan Yin, who responds to the suffering of her people. She is the Great Mother who was named "The One Who Hears the Cries of the World." She is the essence of compassion.

120 Julia Kristeva, *The Kristeva Reader*, p. 170.
121 Ronald Lightbrown, *Piero della Francesca*, p. 30.

Mary expresses something of this compassion for her people. Its meaning is echoed in a prayer from the book used by the Confraternity of Santa Maria:

> Kindly Queen, crowned by heaven, consecrated to the Holy Spirit, with humble and pious voices we pray thee, extend thy noble mantle over this devout company, receiving the anguished tears of this people, that prays to thee so tenderly with ardent voice.[122]

Perhaps the artist knew this prayer. In any case, his feeling of reverence infuses his painting.

Piero crowns Mary with a gold circle and halo, symbols of her holiness. Her hair is drawn back and she looks with compassion down on her followers. She is pictured as a noble woman. "The pose is a consummate fusion of a graceful action of protection, just sufficiently indicated, with the statuesque majesty of an iconic image."[123] Here Piero combines a contemplative "other worldliness" with a powerful "this worldly" female presence. Here Mary is not an impersonal protectress. Rather she seems to make a gracious motion toward those who are imploring her aid. As the word "com-passion" describes an awakening of the heart, so the image stirred in me again a longing for the Divine Feminine.

The Madonna makes a powerful statement as she lifts her arms in a gesture of embracing all who seek her help. As with the Chinese Goddess Quan Yin, people feel they can ask Mary for ordinary everyday needs: to pass a test, to find the right job, to have a healthy baby. The people kneeling before her represent men and women of all classes, rich and poor, bishops, widows, including a hooded member of the Misericordia Confraternity. (Wearing the hood allowed one to perform good works with certain anonymity.) "These people were all members of the church," I mused. Was the artist, himself living in a male dominated society, conscious of the strong statement he made about Mary's accepting all equally? I am reminded of the Mexican image of Our Lady of Guadalupe. There Mary reaches

122 Lightbrown, *Piero della Francesca*, p. 43.
123 Ibid., p. 40.

out to the Indians, put down and discredited by their conquerors. She names them "dignified" people of God.[124] Mary accepts all equally making no distinction based on gender, color, race or religion. There are no second class citizens here.

Majestic in her crimson gown and her outer cape, Mary lifts her arms creating a tent like space which protects her people. Some might say that devotion to her makes us infantile, children looking up to a great mother. I feel, rather, that the image suggests a "holding" and support until we can affirm that "divine" within ourselves, our inner "ground." This Madonna image suggests to me not only the meaning of temple as "temenos," (sacred space) but an inner place where we can be ourselves. Flannery O'Connor expresses the idea in her story, "A Temple of the Holy Ghost." A twelve year old girl struggles with her inability to "fit in" with the world of her cousins and their craze for boys and clothes. At school the nuns teach her that we are temples of the Holy Ghost. While her cousins laugh at the idea, she finds the phrase meaningful. As the phrase seeps into her consciousness, she begins to feel more inner strength. Slowly she begins to accept and value herself as she is.

Sallie McFague writes that Mary's saving power has to do with preserving what is inherently good, saving us from our own unjust action, saving us from the effects of unjust treatment we have experienced from others.[125] This Madonna's posture is not passive. It suggests a "containing" that fosters life and frees us to be more fully who we are. It took me years to see in this image of Mary the Divine Wisdom-Sophia, as imaging the spiritual ground of my own being. Given her size and regal bearing, I began to sense Mary as continuing the legacy of the ancient Divinities, the great Egyptian Isis, or the Sumerian Goddess Inanna.

Historically we have seen that numerous churches dedicated to Mary were formerly temples where ancient female gods were worshipped. Of note is the beautifully impressive Cathedral

124 Virgilio Elizondo, *Guadalupe: Mother of the New Creation*, p. 84.
125 Sallie McFague, *Models of God: Theology for an Ecological Nuclear Age*, p. 130.

of Ciraco in Ancona, Italy. Located on a hill overlooking the Adriatic and the Ancona seaport, this temple invites its visitors to imagine the great tradition of female gods as well as Mary, their successor. When I stood inside this magnificent structure, I looked through a glass enclosed portion of the floor down through three or four levels showing the remains of earlier temples. The earliest, from 380 BC, was a temple dedicated to the Greek Goddess Aphrodite. Standing on this spot, I experienced a sense not only of history but of the millions of our ancestors who worshipped the Goddess as full expression of Divinity.

In both Jewish and Christian tradition this "She" referred to Sophia, the name given to Wisdom. I had often meditated as a religious novice on the Wisdom literature in the Hebrew Scriptures since it was the only place where I found reference to a feminine divine energy. Still the Wisdom I learned about seemed rather abstract, not connected to a female divinity. Yet the title had been attributed to Mary. She is called Daughter of Wisdom and Wisdom Sophia. How, I wondered, did the ancient idea of Wisdom relate to a feminine divinity whether as a goddess or as Mary?

Biblical scholars provided the answer. It seems that for years they had searched for the mythic root of this feminine Divine image, not easy since Wisdom has so many names.[126] She is Mother and Virgin and Wife. She is both created by God, and is alone herself the creator. At times she is God's wife or helpmate. But scholars found one goddess who was widely worshipped and who united these various aspects in herself. It was the Egyptian Goddess, Isis, who was loved and worshipped for thousands of years before Christianity. There are numerous references to Isis as Sovereign Overseer of the World. She ruled the stars and the sea.

Unlike the description of God as Being, Isis is Movement. She is "the breath of God." She has journeyed through upper and lower worlds, the circuit of heaven and earth. She is the goddess of rebirth and transformation. Some of the images which

126 Hans Conzelmann, "The Mother of Wisdom," in *The Future of Our Religious Past*, p. 234.

describe Isis are found in the Hebrew scripture in the books of Wisdom and Sirach:

> I came forth from the mouth of the Most High
> And covered the earth like a mist.
> I dwelt in high places,
> And my throne was in a pillar of cloud.
> Alone I have made the circuit of the vault of Heaven
> And have walked in the depths of the abyss.
> In the waves of the sea, in the whole earth,
> And in every people and nation I have
> Gotten a possession.
> Among all these I sought a resting place. (Sir: 24:3-7)

Paradoxically the temple image expands to a more abstract and cosmic dimension, yet, at the same time, becomes more personal. "Wisdom exists from the primordial beginning, but in a hidden form, so that she must be sought..."[127] Today numerous women are seeking her whether as cosmic energy or in images like the Black Madonna. Linking Wisdom, Isis and Mary enriches my experience of Christian tradition. I feel kinship with the women and men who honor Isis as Goddess of Wisdom and today honor Mary as an image of Wisdom.

The poet Gerard Manley Hopkins knew Sophia Wisdom. In his poem, "The Blessed Virgin Compared to the Air we Breathe," he imagines Mary as a cosmic spiritual temple. She fills the whole world. She is compared to the air we breathe, which without we cannot survive. Mary as spiritual temple gives life and power to all men and women who are in tune with their own inner rhythm. For this is the rhythm of the universe reflected in the simple act of breathing in...and breathing out.

> Wild air, world mothering air,
> Nestling me everywhere...
> This air, which, by life's law,
> My lung must draw and draw
> Now but to breathe its praise,
> Minds me in many ways
> Of her who not only
> Gave God's infinity

127 Conzelmann, "The Mother of Wisdom."

> Dwindled to infancy
> Welcome in womb and breast,
> Birth, milk, and all the rest
> But mothers each new grace
> That does now reach our race—
> Mary Immaculate....

Usually we so take our breathing for granted that we are unaware of it. For Hopkins it is a reminder that we truly live in God.

The mystic's quiet prayer of presence is simply "being there" in God. Hopkins echoes a scripture text, "In him (her) we live and move and have our being."

> I say that we are wound
> With mercy round and round
> As if with air; the same
> Is Mary, more by name.
> She, wild web, wondrous robe,
> Mantles the guilty globe...
>
> And men are meant to share
> Her life as life does air.[128]

As a kind of world soul Mary as "world-mothering air" enfolds us, protects and guides. Within this cosmic temple we find our own ground and the freedom to breathe in our life sustenance. I imagine in the Misericordia painting Mary's uplifted arms enfolding ordinary men and women seeking to experience a greater power, a sustaining Presence. Entering Hopkins' temple metaphor, Mary as "world-mothering air," we can never be far from God, for God is closer to us than our breath.

In Christianity we have lost the image of Wisdom as She who was "before all things."[129] Biblical scholar James Robinson writes, "The survival of Wisdom in the top echelon of deity would have assured a female part at the top (which may be part of the reason that Wisdom was dropped). Wisdom was fad-

128 Gerard Manly Hopkins, *God's Grandeur and Other Poems*, pp. 39-40.
129 Elaine Pagels, *The Gnostic Gospels*, p. 65.

ing fast by the time the New Testament was written."[130] Christianity was more influenced by Greek Hellenism including the idea of masculine superiority, than by the Wisdom tradition. Yet some exquisite Wisdom verses were included in the liturgy and gradually Wisdom's titles were attributed to Mary.

But this was not enough. There has always been the longing to see Mary (representing a Female Divinity) officially represented as such. I was pleased to read theologian Leonardo Boff on Mary. He imagines that the Holy Spirit indeed made Mary a temple. As the Holy Spirit (Gen. 1:1) descended in the act of creation at Jesus' Baptism and at Pentecost (Acts 2:2) so at the Annunciation (Luke 1:37) the Spirit bonded with Mary. And this Spirit as transforming power invites us to respond to its invitation.

Boff sees Mary's cooperation with God at the Annunciation as a receiving of the Spirit's Presence. The Spirit assumes her as the locus of the Spirit's presence and activity in the world. From the moment of her "Fiat," Mary is hypostatically assumed by the Third Person of the Trinity.[131]

Mary is raised, at this moment "to the level of God in order to be able to engender God."[132] What happens at this instant, Boff imagines, is what happened when as traditional theology expresses it, the Second Person of the Trinity took human nature in Jesus. While, in Boff's view, Mary's divinization is in the plan of redemption and salvation, he feels that Mary has been worshipped for centuries, probably unconsciously, as a female Face of God.

This phrase, Mary as Face of God, reminds me that in 1950 when Pope Pius XII proclaimed the Assumption of Mary a dogma (a popular belief since the 6th century) Mary was truly pro-

130 John Robinson, "Very Goddess, Very Man," in *Images of the Feminine in Gnosticism*, ed. Karen L. King (Philadelphia: Fortress Press, 1988), p. 119.

131 Leonardo Boff, *The Maternal Face of God*, p. 100. See also St. Maximilian Kolbe who says that the Spirit is "quasi" incarnate in Mary. H.M. Manteau-Bonamy, O.P. *Immaculate Conception and the Holy Spirit, The Marian Teachings of St. Maximilian Kolbe* p. 61.

132 Ibid.

claimed Queen of Heaven along with her Son, the King, Jesus. At the time I did not understand the symbolical meaning of this new feast. I had even imagined Mary floating up to the sky, but I knew there must be a deeper meaning. Jung writes that the Coronation of Mary showed a longing in the masses for an intercessor and mediatrix who would be Queen of Heaven, the heavenly bride united with the bridegroom.[133] Lily in *The Secret Life of Bees* by Sue Monk Kidd, looking at a statue of Black Mary says. "I feel in unexpected moments her Assumption into heaven happening in places inside me. She will suddenly rise and when she does, she doesn't go up, up into the sky but further inside me...into the holes life has gouged out."[134] In an over rational world, the longing for the Divine Mary had found its voice in Mary's Assumption and Coronation.

Here the intuitions of the past and the present affirm what millions of women and men throughout the ages have felt. They have "tuned in," as it were, to the older tradition (primitive Christian-Jewish) honoring Wisdom as the highest image of God. She has spoken down through the ages through various persons whom she has inspired:

> Though she is but one, she can do all things, and while remaining in herself, she renews all things; in every generation she passes into holy souls and makes them friends of God, and prophets. (Wisdom 7:27)

Wisdom is self-generative, a quality attributed to the Virgin Goddesses. While Wisdom remains in herself, she passes into holy souls throughout time. Wisdom as the Holy Spirit "passed into" Jesus at his baptism. Attributing Wisdom titles to Mary, men and women through the ages, perhaps unconsciously, sensed that Wisdom, too, "passed into" Mary.

Then, we might speculate that Mary, like Jesus, was inspired or "possessed" by that Spirit of Wisdom. Mary is imagined as

133 *Psychology and Religion*, CW Vol. 11, p. 463. For Jung the Assumption of Mary is a compensation, though incomplete, for an over-masculinized God image.

134 Sue Monk Kidd, *The Secret Life of Bees* (New York: Penguin Books, 2002), p. 302.

the tabernacle and temple of the Spirit and what we have attributed to Spirit belongs to her. She in turn gives us the power to recover a vision of ourselves and others as "temples." In the Hebrew scripture the Spirit is imaged as the Shekhinah, the Presence of God that hovered over the tabernacle (Exodus 40:34-8) and the feminine Divine presence within the soul of every man and woman. This presence is related to Wisdom-Sophia, the Wisdom who protects and guides us. As the cosmic soul, she is imaged as present in Mary, "world-mothering air."

Another aspect of the temple is its relation to the center of the earth. Like the cosmic tree or mountain, this center, it was believed, was the place where everything originated in the Original Mother (Wisdom). This was the place where our ancestors believed the shamans and the gods mediated between the three levels of the world: the heaven, the earth, and the underworld. But what could this image of temple have to do with Mary? Certainly Mary is not viewed as mediator between the three realms. Yet this is a role of Sophia Wisdom. She "encompassed the circuit of heaven, and walked in the bottom of the deep." (Sirach 24:5) As Sorrowful Mother, Mary experienced the depths of grief. Under her title of Sophia, Mary has been invoked as the guardian of a hidden treasure which women who claim her as the dark Mother or Black Madonna seek within themselves.

We have noted how in the alchemical texts related to the early science of metallurgy the ores in the earth could be ripened over time. They ripened into gold. Down in the depths of the earth imaged as womb is the hidden ore, referred to as embryo or hidden child or treasure. Mary has been invoked as the guardian of this treasure which the women who claim her as their dark Mother seek within them when they feel confused or depressed. The treasure, as so many women have expressed it, is finding "my voice." It is the treasure reclaimed through suffering which brings peace and freedom and joy.

Frederick Franck and *The Vierge*

It was in a 20th century sculpture by artist Frederick Franck and a medieval sculpture of Mary *The Vierge Ouvrante* that I began to sense more clearly the connection between these images of Mary and the *Misericordia* painting by Piero della Francesca. The center of her power is "cordia," the heart. She represents the giving and forgiving heart of the Cosmic Mother. The next two pictures lead us to another level where the artists seem to intuit the essence of the imageless origin of all. In *Vierge Ouvrante* the artist carved within a Cosmic Mother image the figures of God the Father and Jesus. In the center of Franck's huge sculpture of Mary is simply a circle (face).

The *Vierge Ouvrante*, shown here dates from the 15th century. These sculptures were formerly called shrine Madonnas and were said to have originated in women's monasteries. When the flaps are closed, this sculpture looks like a traditional Madonna holding her infant Son. When it is opened ("ouvrante"), it reveals God the Father holding the Son crucified. One way of viewing this piece is heretical to Christian tradition, but it does offer a magnificent image of Mary as the Mother God of Christianity.[135] In these figures, we can imagine Mary as the Temple who contains Father and Son; She is larger than they. Carrying this image further, we can imagine Mother God enclosing the Father God who rests in her lap. And the Father God holds the Son, crucified. This image fuels my intuition and desire to see Mary as a Wisdom figure, an echo of the "She who is before all things."[136]

The earliest *Vierge* sculptures appeared probably in the 12th century influenced by medieval mysticism. Some problems arose in succeeding centuries with the Church's acceptance of the figure. Theologian John Gerson (1363-1429), warned that the image should not be interpreted that the Trinity had taken

135 Neumann, *The Great Mother*, p. 331.
136 Pagels, *The Gnostic Gospels*, p. 65.

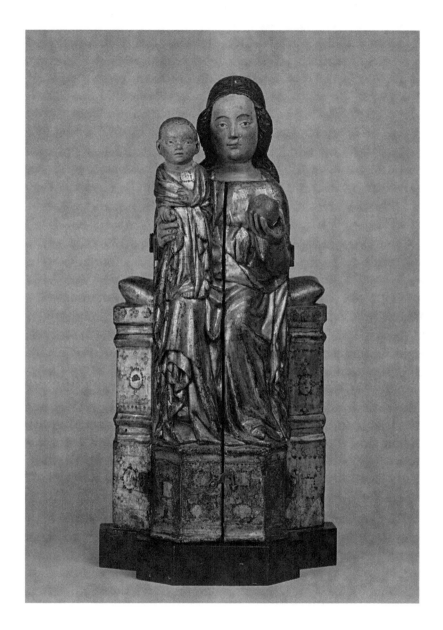

Vierge Ouvrante (closed) 15th Century. Musée de Cluny.

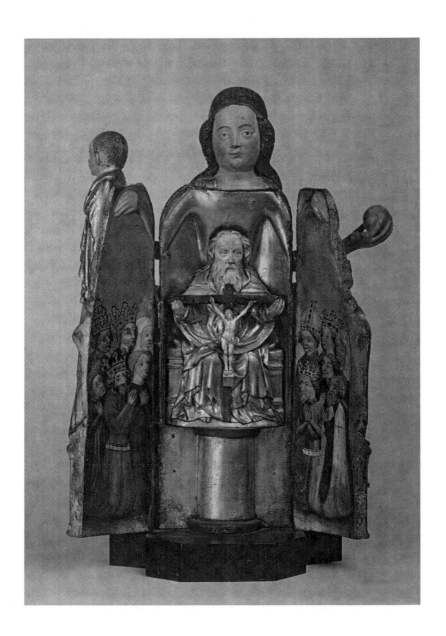

Vierge Ouvrante (open) 15th Century. Musée de Cluny.

a body in Mary's womb.[137] In 1745 Pope Benedict XIV warned against representations of this Madonna which probably explains why there are not many "Vierges" seen in churches or museums today. Yet it may be that the sculpture expressed the mystical vision of the Great Mother as Source of Life. Taken psychologically, then, the image gives form to the matrix (psyche) out of which all ideas, philosophies, and gods are born. Here the matrix is imaged as Mary the "Vierge." But by attribution we can imagine that Creative Feminine Divine Spirit present as our inner "ground."

This image of *Vierge Ouvrante* also suggests that bound up with God, the Great Mystery are both fear of God and suffering as part of our God experience. Except in Michelangelo's "Pietas" we hardly see Mary full front presenting, as it were, the image of a suffering god. Mary, true, is the sorrowful pieta, lesser than her Son in the tradition. In the *Ouvrante* she reveals the plan of God's self expression...not only in loving compassion but in suffering. Suffering and pain are not only part of her message, but of her being. What is the place of suffering in a God of Love? The question has been asked over and over again. Mary as "Vierge" seems to suggest that suffering is a most important part of the way. Here, perhaps, it is only the mystics who truly see suffering as an expression of love.

At the same period of history that the "Vierge" statues appeared, the Beguines, a group of women mystics struggled with the paradox of suffering and a God of Love. They were lay women who lived a life of poverty and chastity devoted to good works among the poor and the sick in Belgium and Germany. Living "in the world," not separated from it, they experienced the daily hardships and sufferings of those among whom they lived. Their writings show how they struggled with the question: *If God is Love, why is there suffering and evil in the world?* The Beguines, at least as they began in the 13th century, came from wealthy and educated families, and their writing reflects this.

137 Correspondence with Johann Roten, Marian Library, University of Dayton.

One of their most famous members, Hadewijch, writes of her experience of God whom she calls "Minne," a feminine word for Love. Though many of her writings address God in loving terms, in one of her poems, she refers to the experience of loving God as "Hell."

> Forever to be in unrest,
> Forever assault and new persecutions,
> To be wholly devoured and wholly engulfed
> In her (Love's) unfathomable nature,
> To founder in incandescence and in cold every hour
> In the deep high darkness of Love
> This exceeds the pains of hell.
> He who knows Love and her comings and goings
> Has experienced and can understand
> Why it is truly appropriate
> That Hell should be the highest name of Love.[138]

Here Hadewijch speaks of her experience of loving God and also of her experience of God. While she feels loved, she also feels at times a misery so intense that "Hell" is the only appropriate word to describe it. While the image of Hell may be somewhat shocking to us in this context, we need to remember that the Beguines were caught up in their own suffering, the suffering of the poor to whom they ministered, and the Mystery of God, the awareness of God as Other, yet immanent. In their prayer they sensed elements of awe and wonder; they experienced effects of the Wrath of God, as well as the Love of God.[139] Like the play of light and shadow in our lives, so they knew God mirrors the whole of human experience.

In the open *Vierge Ouvrante* we focus on Jesus stretched on a cross, the "Man for Others" bearing with dignity undeserved suffering and humiliation. Many Galilean townspeople may

138 Saskia Murk-Jansen, *Brides in the Desert*, p. 55. (Poem from *Hadewijch: The Complete Works*, 16:158-164.

139 Compare similar insights in Sufi thought with the poet Rumi. "How much the Beloved made me suffer before the Work/Grew entwined inseparably with blood and eyes!/A thousand grim fires and heartbreaks—/And its name is "Love." Harvey and Baring, *The Divine Feminine*, p. 124.

have remembered this Jesus as a prophet sent by the Divine So-
phia who was executed but was still remembered as the Living
One.[140] The cross is one of the oldest symbols for harmony and
order, for wholeness. It reminds us that each of us must bear
our own "stretching" into becoming fully human. The *Vierge
Ouvrante* reminds us that Mary-Sophia is holding us and loving
us into fuller Life.

Frederick Franck and *The Original Face*

Contemporary artist Frederick Franck liked to work with analo-
gies and connections and felt the need to create images of Mary
as a way to explore likenesses between many traditions. His in-
spiration for the work shows this. "Though I was not a member
of a Christian community, I grew up in Maastricht, Holland,
just on the Belgian border, where Mary's presence was every-
where, and I picked up Catholic symbolism by osmosis."[141] He
was attracted to the rituals of Catholicism and to the statues
and paintings of Mary especially those depicting her as Mother
of Mercy. He felt that it is important for women today to be-
come more fully themselves. Mary as source of all life became
for him the heart of that search.

I was attracted to Franck's sculpture (icon) of Mary when I
read Sally Cunneen's classic book, *In Search of Mary: The Woman
and the Symbol*. Wishing to see it for myself, I telephoned the
Francks and was surprised to hear a soft-spoken "hello" on the
other end. This was not the secretary, but Claske, Frederick's
wife of some sixty plus years. She said they would welcome
me and gave me directions to their home, "Pacem in Terris" in
Warwick, New York. On a sunny April afternoon I arrived at
"Pacem." Claske greeted me and walked with me to the gar-
den in this enchanted place (an old water-mill converted into
a kind of Alice in Wonderland sculpture garden), where stood

140 Elisabeth Schüssler Fiorenza, *Sharing Her Word*, p. 175.
141 Cunneen, *In Search of Mary*, p. 325.

Frederick Franck. *The Original Face Concealed* (Variation on a 15th C. "Vierge Ouvrante") "Pacem in Terris" Warwick, New York.

the seven foot steel sculpture of Mary, *The Original Face*. Franck's version of "Vierge" differs visually from the medieval one. Here there is no image of crucifixion: The Virgin's cloak opens to reveal the circle face. When it is closed we see only the Madonna. I remember standing before this image in Franck's garden. For a moment I felt enveloped by its aura.

The title for *The Original Face* comes from the Zen koan: "Show me your original face, the one you had before you were born." A koan is a conundrum that shakes the rational. We cannot figure it out and that is the point. We are brought to a stand-still, into a realm of "not-knowing," beyond knowing in the usual sense. The koan is meant to lead us to and leave us in mystery, without image, where we sense at times a dark night, a nothing, or a pregnant emptiness. Pondering the words "before you were born" brings me to a sense of nothingness, aloneness. And often in that aloneness, if I have the courage to stay with it (when I want to run for some distraction), I sense that I am alive with another's life. And I call her Sophia. In Franck's sculpture Mary becomes both the "container" and the source of this life.

I had not been aware that in the Judeo-Christian religion Sophia was present as Queen. From early on (6th century BC) there were two traditions derived from the early religion in Jerusalem. One was centered on the Law of Moses and the other on Wisdom, the Queen of Heaven. The Jews living in Egypt kept their worship of the Goddess and it was through them that the tradition was passed to the early Christian communities. These Jews were probably influenced by the early Gnostic Christians who revered Wisdom in her cosmic dimensions as womb or creator of the world and all life.[142] I began to see Mary and her temple "cloak" in "Vierge" and "Original Face" as opening me to that larger cosmic temple.

142 Margaret Barker, *The Revelation of Jesus Christ*, p. 206.

Frederick Franck. *The Original Face Revealed* (Variation on a 15th C. "Vierge Ouvrante") "Pacem in Terris" Warwick, New York.

What is your Original Face?

What is our face? Does it reveal our character? We like to present our "best" face, and what is that? The great Italian actress, Anna Magnani, is supposed to have told her make-up man, "Don't take out a single line. I paid for each one."[143] French thinker Emmanuel Levinas says that our face bears only one message: our utter vulnerability.[144] According to Hillman, age has nothing to do with a flight from our sense of weakness. People of all ages frequent the cosmetic surgeon. But life changes us revealing through us more than we know. Looking at a later Rembrandt self portrait, do we not see the invisible beauty shining through an aged, puffy, blotchy face? Do we catch a "glimpse" here of the Original Face?

As we strive to express the inexpressible, we grope in poetry, music and art, in movement, dance and prayer to image the unknown. "What is your original face?" The koan brings us into the feminine way and an important part of this way is living with ambiguity. For those of us more comfortable in the rational realm, eager to control, to know, and to analyze, this place of unknowing stops us short. Trusting in this grace, we rest. And soon the forms begin to dance before our inner eye. And we let it be. In some mysterious way I begin to find the Feminine Face of God in the faces I meet. And, at times, Mary's face fades into nothingness. How can we find words to express a non-image? I was going to suggest that it fades into the Invisible Face within the All.

Buddhist scholar D.T. Suzuki once said that we bring a koan along with us into the world and we try to decipher it before we die. Each koan, like "your original face," places before us the ultimate question of the meaning of our existence. Our mind may grapple with the koan but we do not approach a logical answer. We are thrown into nothingness, a void, into Reality. And we find solace in the treasured stories that suggest our pre-existence. In the "Hymn of the Pearl" (See Chapter Two) the

143 James Hillman, *The Force of Character*, p. 138.
144 Ibid., 141.

hero leaves his robe in heaven, and on his return his Robe of Glory comes to meet him. "It seemed a mirror-image of myself: myself entire I saw in it..."[145] The Robe represents the original idea of his identity. Meeting his Robe of Glory, he meets his eternal self, or as the Sufis name it, his Supreme Identity.

William Butler Yeats suggests that in our attempts to beautify our face we are searching for this reflection. We are searching for the face we had "Before the World was Made."[146] That is, even in preparing to "meet the faces that I meet" I am looking for the real self, the free self, for wholeness. As the baby looks into its mother's face to discover itself so we must look into the "Face" of God to discover our Original Face. Frederick Franck, echoing Yeats, calls this realization of the Face our true humanity.

In Franck's sculpture the face etched on Mary's breast is the heart that opens to the Sacred. The Face represents our original pattern and our return to the Source. But even more importantly it is our *Now*, our present seeing through each other's face into the Mystery that we are now. And I like to imagine this Face shining through the eons as Wisdom Sophia. She speaks:

> In the stirring of the layers of the cosmic substance, whose nascent folds contain the promise of worlds beyond number, *the first traces of My countenance could be read...* I was the bond that thus held together the foundations of the Universe.[147] (italics mine)

In Her we are united at the deepest level.

Both the *Vierge Ouvrante* and *The Original Face* by drawing us into the Origin, draw us into our oneness with each other. The circle is probably the oldest image for God as Divine Feminine. In the circle as God image and as void we experience the opposites: suffering, destruction, compassion and creation as one. In the Original Face all religious traditions converge at their root, often named Wisdom Sophia. While many of the ancient

145 Edward Edinger, *Ego and Archetype*, p. 159.
146 W.B. Yeats, *The Poems*, p. 275.
147 Teilhard de Chardin, "The Eternal Feminine" in *The Prayer of the Universe*, pp. 143-144.

Female Divinities have been lost to mainstream Christianity, Mary remains as their cosmic echo. As the Temple of Wisdom she attends to the depths of humanity in its suffering. She also symbolizes its transforming power through her love and compassion. In these qualities lies her greatest power.

"Mythology," writes Karen Armstrong, "is an art form. Any masterpiece of art invades our being and changes it forever."[148] So it has been for me, both the Christian myth and the art it has inspired through the ages. Great Marian art's "invasion" has drawn me into the deeper dimension that Jung calls the Self, the inner God image and guide. I am changed. But personal change comes slowly, imperceptibly, usually over many years; it seldom happens dramatically. Within the temple space the god/goddess is housed. The Spirit of the Temple where the mysteries, rituals and texts evoked God's Presence has "moved" within. It has always been there. Each of us is a temple. There is no supernatural "invading" or making "holy" the natural. It is a question of becoming attuned to the soul. The mysteries of life, death and transformation, the myths, are lived out in the flesh of our daily joys and struggles.

The Annunciation image awakens us to possibility and hope. It evokes joy at new beginnings, for each stage of life is a new beginning. The Pregnant Virgin as temple honors physical motherhood as the sacred vocation it is, while reminding us of our spiritual pregnancy; we are "favored of God." The angels are still sending us messages often through our dreams. Following along the path of my own awakening, dreams often lighted the next step of the way. From the religious collective images of Mary, I turn now to dream images and to my "stone dream."

148 Karen Armstrong, *A Short History of Myth*, p. 148.

Sounding the Stone Dream

"Know thyself."

—Inscription at the Temple
of the Oracle at Delphi

Angels are said to announce momentous changes that have an effect on our entire life. It is as if the angel intuits our destiny and empowers us to fulfill it. Gabriel tells Mary that her vocation is to bear Jesus who will be the Christ. And our personal angel calls on us to bear our "child," our life, our unfolding destiny. Annunciation is synonymous with pregnancy, new possibility and hope. This may explain why women often dream that they are pregnant. These may be wish dreams but they often refer to a psychic stirring, something within the personality that wants to live. After my first Jungian therapy I dreamed that I was happily pregnant. My mother appeared, as I had seldom seen her in real life, radiantly smiling at me. I took this dream to mean that something dead or "sleeping" had come alive in me, something related to mothering and to the feminine.

The year before I left for Zürich I had another pregnancy dream. A male and a female doctor were attending me. When it came time to give birth, I brought forth not a baby, but a stone. The stone, about the size of an orange, was held up to the light and seemed to take on a glow of its own. In the dream I did not feel badly about this "birth" though I found it puzzling. I knew that the dream was not to be taken literally as physical infertility. But what was the psychic meaning? In my first inter-

view with a Jungian analyst I mentioned the dream. He posed a question. "Well, did you ever hear about the "philosopher's stone?" I hadn't. "Have you heard the Biblical story about the stone which the builders rejected?" Yes, I had heard that but what did it have to do with the dream? I don't remember whether the analyst explained what the "philosopher's stone" is but, in any case, the discussion was not helpful. (Actually the dream did have connection with the alchemical "philosopher's stone" but that insight came years later.)

I put the dream on an inner shelf. Three years later I made an appointment with Aniela Jaffe, Jung's friend and, for many years, his secretary. A few lucky diplomate candidates did analysis with her. Others made appointments for one or a few hours. Except for meetings with members of Jung's family, a visit with Aniela was as close as one could get to meeting with Jung himself. I wondered what I could talk about and the hidden dream came to mind.

Jaffe, then in her eighties, read the dream and looked up at me, her eyes sparkling. "Wounding in the feminine, but you have a gift!" By gift she meant the stone. How, I wondered, could a stone be a gift? And what was the feminine? I had so much to learn. At the time I thought I needed intellectual learning. Reading books and more books would provide answers. But I really needed to come down out of my head. In a way the stone dream imaged the path to my healing. At first I had to discover how I *was* "stone." Then, and only gradually, I could relate to and experience the stone in its spiritual meaning. Coming to experience this inner reality is the goal of analysis.

Working with the stone dream long after my visit with Aniela, I associated to the word "stone" hardness and coldness. Yes, only when I began to relax, to "thaw," was I able to feel how rigid and tense I had been. Stone-like women (and men) are controlling, unloving (since they do not love themselves), and unrelated except in a superficial way, often appearing to others as somewhat aloof. One effect of this wounding is a kind of compulsive doing, physically or mentally. I crowded into the day more than it could hold; at night my thoughts whirled

around what I did or did not get done. On and on, the list never seemed to end. I realize now how this compulsion soothed my sense of emptiness.

Dreams often reflect society or the collective. I began to realize that my stone dream, a "snapshot" of me from my unconscious, also described a collective situation. Not only had I been "numbed out" in *my* body but many of us, women and men, suffer from becoming "stone like" in body and soul. As we know, water smoothes stone as nothing else does. As I began to "thaw" I was able to cry, more often alone than with my analyst. Years later in my own consulting room women (and men) have been moved to tears. Some people express the *need* to cry. Often they do not know why. One woman in her 60's came to therapy with this problem: "I feel I have tears stuck in the throat." Tears melt body hardness and tension. In resurrecting our body, we begin to recover our feminine softness and strength, our spontaneity and suppleness, our sense, that, indeed, we *are*. A stone is moved by others; it cannot move itself.

I thought of women who for centuries were told, "This is your place in society; don't think of moving from it." Now in our descent to body, our "earth," maybe we can begin to recover our power to move, to choose, to be free. Descent from the thinking and doing mode to feeling our own experience is a letting go. And this is the beginning of healing. My own wounding in the feminine meant that I needed more "earth," not only gardening and walking in the woods; I needed to move downward into the earth spirit realm, into my inner world, into its darkness and rage.

Jungian analyst Patricia Berry refers to this feminine earth-spirit in her essay "What's the Matter with Mother." Mother Earth, Gaia, is experienced on two levels, the literal or concrete and the invisible or spiritual. Berry feels that we tend to take earth more literally than we take the other elements, water, air and fire. So in therapy we might suggest to a person wounded in her feminine nature that she take up gardening or knitting. Yet one could be growing herbs and vegetables and still be spinning in her thoughts and her emotional life. This would show

that she still had very little psychic grounding. "So it isn't really just *physical* earth that connects us to the divinity of Mother Gaia, but psychic earth, earth that has become ensouled with divinity.....touched by the metaphorical Muses of soul."[149]

Only then can a woman find her own spirituality, her "ground." This is the second level of Mother Earth. It is invisible and somewhat chaotic, it is dark. In the land of "shades" is where we experience ourselves, in black moods, limitation, loss and despair. Ironically, many who find themselves in a "down" mood turn immediately to stimulants to deliver them. But when we are here, we are at the *ground of ourselves in the psychic earth.* And here we can discover possibility and hope.

This "descent" into earth is necessary for the recovery of the "inner child," that vulnerable yet potentially powerful side of us. It is an apt image. Women and men often compensate for a sense of vulnerability by *over* achieving. When parents put too much pressure on children to succeed, to "make it to the top," there is great danger that the *real* child/adult will be numbed out, metaphorically turned into stone. For several decades we have seen a more feminine ego coming into its own to balance our over rational pressurized approach to living. With this awakening in woman comes a realization that her way of achieving may at times follow a different path.

The feminine way of understanding begins with an intuition. It is like a conception.[150] It takes time to bring this intuition to birth. A woman lets it go and then returns to it. If she is in a hurry, trying to force her thought or her self into a way not hers, she will lose the thread. Feminine knowing, like moon consciousness may not shine brightly, but it is true illumination. This living with her creative power, feeling it, taking steps to give it form, begins to fill what, for many women, had been felt as the gnawing inner emptiness of the "lost" child. Metaphorically speaking, in that realm of earth, psychic earth, we discover a fuller measure of our self. The meaning of any dream

149 Patricia Berry, *Echo's Subtle Body: Contributions to an Archetypal Psychology*, p. 8.
150 Ulanov, *The Feminine*, pp. 172-173.

image can change over time. I began to see the stone image in a more positive light as it began to mirror my own healing. I realized that a stone is permanent, and solid. Symbolically speaking, a stone is not dead, or cold and rigid. Medieval alchemists wrote that the stone contains light and fire in its center.

The medieval alchemists called a unique stone the "orphan stone," a gem similar to the modern solitaire.[151] And this stone they equated with "the philosopher's stone," the goal of personal fulfillment. It represents the Divine within oneself. For the ancients, the stone symbolized "the essential being: the soul or spirit of animate life that was not subject to decay but endured beyond and beneath all appearance."[152] The stone represents an immortal healing balm within. For Jung it represented the immortal Self.

St. Teresa of Avila taught that the power to change lies within us. While drawn to a life of contemplation in her monastery, Teresa was called to be a reformer, to effect change in the religious orders of her day. Change, personal and societal comes when control, greed and violence give way to relatedness, compassion and love. This journey, personal and societal, is the way to balance and healing. Teresa writes about the stone as gift. It is only when we have suffered the awakening to our own truth that we become aware of the gift. That is, we discover the gift only by living through the journey of self knowledge. Teresa writes, "It is as though we had in a gold vessel a precious stone having the highest value and curative power...through experience we have seen it has cured us."[153]

Who *are* you when all the props are gone, when you have nothing to lean on? asked Jung.[154] Are you related to something

151 Rose-Emily Rothenberg, *The Jewel in the Wound: How the Body Expresses the Needs of the Psyche and Offers a Path to Transformation*, p. 47.

152 Baring and Cashford, *Myth of the Goddess*, p. 96.

153 Teresa of Avila, *The Interior Castle*, p. 116. In Medieval lore this healing stone or vessel was also an image for Mary. "The uterus is the centre, the life-giving vessel. The stone, like the grail, is itself the creative vessel, the *elixir vitae*." (Alchemical note on the figure of Mary in Jung, CW 12, p. 179.)

154 Jung, *Memories, Dreams, Reflections*, p. 325.

Infinite or not? This is the supreme question in life. Jaffe told me that one day she saw Jung chipping away at a stone in his private retreat at Bollingen. The stone got smaller and smaller. And finally he held it up. When we can admit to ourselves that we are small and limited, "only that," he said, this is the moment when we can experience the Infinite. I knew this, intellectually. Now I began to experience moments of God's presence to me in my smallness. The poor and dispossessed, the marginal in our world and all who have experienced the nadir point of hopelessness, come to this reality more often than we imagine. Many of these poor are the true mystics of our time and I feel that most of them are women.

Jung, drawing on alchemical writings, expressed these ideas on a large stone at his retreat house in Bollingen. He planned to build a monument out of stone but a mistake was made in the measurements of the cornerstone. The mason wanted to send it back but Jung refused. He had an idea for making the large stone into a little "monument." On one side of it he carved these words:

> Here stands the mean, uncomely stone,
> 'Tis very cheap in price!
> The more it is despised by fools,
> The more loved by the wise.[155]

These words refer to the alchemists' stone which is despised and rejected yet of great value.

Jung then added additional quotations from alchemy, here from a Latin inscription:

> I am an orphan, alone; nevertheless I am found everywhere. I am one, but opposed to myself. I am youth and old man at one and the same time. I have known neither father nor mother, because I have had to be fetched out of the deep like a fish, or fell like a white stone from heaven. In woods and mountains I roam, but I am hidden in the innermost soul of man. I am mortal for everyone, yet I am not touched by the cycle of aeons.[156]

155 Jung, *Memories, Dreams, Reflections*, p. 227.
156 Ibid.

Here the stone speaks of itself as orphaned; found everywhere; it is of little or no value, yet, psychically, it represents immortality.

On another side of his stone Jung had thought about carving some reference to Merlin, a kind of Mercurius figure in alchemy, an agent of change. This would have been appropriate, I think, since this figure can stir up a devious, devilish chaos within us even when we feel rooted in our "God ground." At such moments we can experience the pull of forces that would diminish our self worth, trying to keep us, as it were, on a worn out life script, on a see-saw of emotional ups and downs. These forces are quick to name our unworthiness rather than our worth and they can jeopardize our plans to follow our dreams. But negative agents, inner "demons" *can* be transformative. The tension they create stirs up much needed energy for life's challenges. Like Jacob wrestling with the angel of darkness, we often face a psychic battle to preserve our authentic self and this in itself can be exciting.

The stone dream in its multiple meanings had become the way as well as the goal, a vessel or Grail present within me. During my meeting with Aniela Jaffe she had asked, "What will you do with the stone?" She referred to a ritual of some kind. I fished for an answer and replied, "I will place it on my altar." (Since childhood, when we had a real altar which my brother had accepted from the nuns who were disposing of it from their chapel, we played at saying Mass. He, of course, was the "priest," and I, the altar girl!) Since those years I always had a corner somewhere set apart for meditation with a favorite icon or statue. I decided to find a real stone to place on my "altar." Gradually I did not need an outer reminder. The mystical stone was becoming a kind of Eucharist that became my inner nourishment and support.

As we have noted, in Jungian terms the Self is an inner guide imaged as Wisdom Sophia, the Buddha, Jesus or the Goddess. (In dreams any image carrying numinosity, inspiring awe or mystery, can represent the Self.) In alchemy it is imaged as the Stone, as worthless and of great value, echoing the two poles of

feeling in the "orphaned" child. I am not "orphan" when, as creature, I am in communion with the Greater Self. Recovering the feminine meant that I had to recover and strengthen my sense of self as woman. Mother is basic here because, as we know, a child's sense of living in her body, of feeling secure as she moves into her life is, in the very earliest stages of development, dependent on the child-mother bonding. But the word mother refers not only to our personal mother but to what lies behind the personal parents.

Jung pointed out long ago that our personal parents present only one aspect of our truth. We have other Parents, the Great Mother and Father, archetypal potentialities within our unconscious. This refers to the motif found in all mythologies, of the dual birth or dual descent. As we have seen, for example, the Egyptian Pharaoh was human and divine. He was "twice-born." Jesus too at his Baptism becomes "twice-born" as the Spirit dove appeared as Sophia Wisdom. The Spirit dove was often referred to as Mother of Christ.[157] And today in Christian churches when we are brought to the Baptismal font, the "uterus ecclesias," we are born as children of God. To remind us of this dual birth we are given "godmothers" and "godfathers."

It is important that we do not "blame" our personal mother or father for what we may feel were their inadequacies. Jung stressed this and rightly so, for our personal mothers especially have been blamed for too much, for many of our illnesses, physical and psychic. Our experience of our personal mother, for example, may have had to do not only with her but with our own unconscious projections on her, positive and negative. Yet, having admitted this, we must still work through *our* experiences in our journey to wholeness, how we felt and suffered, accessing our emotions and working to express them. Then we may come to a mature view, seeing our family as the one we *needed* to become who we are. After we have gone through a long journey to self knowledge, "we can see our parents and the events caused by them as actually our own fate (and not

157 Baring and Cashford, *Myth of the Goddess*, p. 629.

our parents' "mistakes").[158] Connecting then more strongly to our soul depths we begin to love our fate. Out of the wound has come a gift!

Coming to know ourselves we come to know God and one another. From childhood my image of God (Self) has been Jesus, the Christ. Now the Mother God image has become an important part of my spiritual life. The capacity for giving and receiving mothering is part of our personal makeup. We seek mothering experiences with others, friends, lovers, siblings and spouses because the "holding" or "bonding" maternal aspect is part of every relationship. We seek mother in the impersonal realm too, in nature, in "Mother Church" and in associations and supportive institutions like religious orders. Nations are called Mother as in Mother Russia. In art like the religious pictures included in these pages, we see how images can evoke the longing for Mother.

This longing for the Mother is echoed in the Hebrew Scripture as the desire to worship the Queen of Heaven, a title Christians gave to Mary. The Queen of Heaven was related to the Moon Mother of ancient times. The Israelites complained that the Queen of Heaven was no longer worshipped. This was not allowed because the Queen resembled the goddess, called by Temple leaders, "Whore of Babylon." But the Egyptian Jews insisted saying, "Ever since we left off sacrificing to the Queen of Heaven…we have lacked everything, and have been destroyed by sword and famine." (Jeremiah 44: 16-19). Their pleas went unheeded, yet their devotion to the Queen or Moon Mother persisted. The Divinity represented as female was on the way out in the Judeo-Christian tradition, yet she remained hidden in its art and ritual.

As we have seen, the moon is an important symbol of feminine puissance. The ancients believed that the Moon Mother creates, dissolves, and regenerates. The moon's cycle programs the rhythm of life, governing the tides, the waters and fertility.

158 Kathrin Asper, *The Abandoned Child Within: On losing and Regaining Self-Worth*, p. 17.

The moon regulates fertility of the earth, the birthing of animals and the growth of plants.

The new moon grows to fullness and then darkens, as the moon eclipses the sun. In this darkness we must imagine its invisible presence. As a thread of light pierces the darkness, we witness the birthing of the new moon. "They (the ancients) call the moon Mother of the Cosmical Universe having both male and female nature"[159] and reproducing herself alone. Women lived their time of pregnancy and childbirth in the cosmic rhythm of the moon in a universal "sacrament" of nature. And they prayed to the Moon Mother for a safe delivery.

Mary is often pictured standing on the moon, a faint echo of the former Moon Mother, and moon qualities have been attributed to her. I have often puzzled over a seeming contradiction. As Mary was honored as Mother of the Church and a symbol of the Divine Feminine, why through the centuries have women found themselves in a subordinate place, unsure of their identity, weakened in their expression of creative power? When men idealize the Virgin in the church and yet women are denied basic rights, what is the psychological dynamic?

Maria Kassel expresses it succinctly from the perspective of depth psychology. If men honor the Mother but are not conscious of their fear of women or the fear of the feminine side of themselves, "the fear of the masculine ego for the feminine is seen as something negative in *women themselves*, and then it is imagined to be right to keep them down."(Italics mine)[160] In our Western culture power often means domination and control, and it is known that what is feared must be controlled. Woman's way, her changeability (a moon quality), her intuition and creativity have been more feared than honored.

It would seem that belief in the incarnation, the Virgin Birth happening in each of us makes for true equality of the sexes.

159 Esther Harding, from the *Plutarch* quoted in *Women's Mysteries: Ancient and Modern*, p. 94.
160 Maria Kassel, "Mary and the Human Psyche," in Hans Küng and Jürgen Moltmann, *Mary in the Churches*, pp. 78, 80.

If God dwells within, "incarnated" in the soul, the "pointe vierge," there are no differences in value between men and women. Kassel continues, "Virginity in the archetype 'Mary' can…. be grasped as a challenge for both sexes to develop their own specific form of psychological independence."[161] The Virgin is one-in-herself, subject only to God alone. As for the Mothering Spirit of God, she does not smother her devotees but fosters their true humanity. Yet granted a centuries' old irrational fear of the feminine, I find it difficult to accept that in the 21st century women are still excluded from participation in the church's priesthood. Neither is there official recognition of the feminine in religious symbols that express Divinity's fullness. But *unofficially* millions take the Cosmic Mary to heart as Divine.

To work for the recovery of the feminine, we must go where the Spirit leads us. For me it means going to the roots of my religious tradition and dreaming its mythic truth onwards. Often in prayer, I rest in an imageless presence. Yet I often call on that mystery in images: Mother, Father, Lord, Spirit, Shepherd, Shepherdess, Friend, Lover, for they stir the heart. Sophia, named, "Stone of Exile," because long ago she was exiled from the Temple, has stirred *my* heart. She is no longer in exile. She lives in Mary as matrix of a new creation, personal and cosmic. In the image of Mary she is like a treasure recovered, a true symbol of the Feminine Divine.

That woman may be accepted as fully human—I once heard this as the goal of the feminist movement. Recovering the feminine mode of being, that is, valuing the non-rational, reverencing nature, the body, and relationships has opened us to an awareness of the Sacred in our culture. This explains why the symbol of Mary emerges for many as a carrier of psychic power. Artist Frederick Franck combines the traditional image of Mary with a Zen koan to suggest that our goal in life—women and men—is to live from our roots, our Original Face, where we are one in kinship with every human being.

It is the artists who can show us the way to the Feminine Self. For great art transports us to our Source, our soul depths. Artists

161 Kassel, "Mary and the Human Psyche."

help us to experience our Origin or Home to which we long to
return not as something that happened in the past or that will
happen in the future, but as life in the present. In *Art as a Way*
Frederick Franck writes:

> The return to the roots is not a nostalgic escapade into the
> past, for these works are of the timeless present. For art is root-
> ed here into that most profound, most specific humanness,
> that core of our being which you and I share with these artists
> we call masters because they had the power to lay them bare,
> these roots, to open our vision to see ourselves as we are.[162]

For Franck this inner power of God is the essence of our human-
ness. And to be fully human is to live in its Presence.

Many women discover hints of this Presence in dream imag-
es that express the Divine Feminine. A woman in her late 60's
came to Jungian analyst Murray Stein saying that her mother
told her it's never too late to grow.[163] She began her therapy
and along the way, as we all do, she became aware of some
of her less attractive qualities. She grieved that she had been
so critical of herself and others, a nagging wife, and she felt,
an inadequate mother. She began the practice of active imagi-
nation in which the ego consciousness, while relaxed, brings
up images as in a waking dream. Often what came up for her
were images of the Great Goddesses and the Quan Yin figure
of Buddhism, compassionate, nurturing deities. Stein felt that
the woman became more human as she identified, not in an
inflationary way, with the Goddess who exhibited the feminine
traits that she herself needed, love and compassion.

The Cretan icon "Kardiotissa" or *Virgin of Tenderness* touched
that need in me. And over time I feel that this Mary as a mythic
image of Goddess, the compassionate loving one, has become a
"mirror" for me. As forgiving one she helps me to forgive myself
and to more easily forgive others. She, as the dark "materia"
is there in times of chaos and I trust that she carries creative
forms into which I can pour my heart's longings. She helps me

162 Frederick Franck, *Art as a Way*, pp. 13-14.
163 Murray Stein, "Individuation: Inner Work" in *Journal of Jungian
 Theory and Practice*, Vol. 7, no. 2, p. 12.

to be compassionate and loving to myself and this enables me to be more loving and compassionate with others. Her love is universal. There are no "superior" or "inferior" people with the Goddess. She encompasses all. She helps me to be open to diversity, to people of different backgrounds, color, religion, sexual orientation. She mothers all.

Mary has been represented in some of the most glorious art the world has known. Masterpieces of traditional art are often passed by because we have attached theological meaning to them which we may have outgrown. But, as we have seen, art as symbol unfolds fresh meaning as we see it through a lens personal to our own seeing. What we discover is the depth of soul common to us all, our common Source or Origin. One of the most beautiful expressions of this Source comes from the Tao:

> The Valley Spirit never dies.
> It is named the Mysterious Female
> And the Doorway of the
> Mysterious Female
> Is the base from which Heaven
> and Earth sprang.
> It is there within us all the while;
> Draw upon it as you will,
> it never runs dry.
>
> *Tao Te Ching 6* [164]

Like Teresa's precious stone, the eternal energy is "there within us all the while."

Images of Mary, traditional and contemporary, show us her liberating power. Great art is a window to the Divine, bringing us to self and God-awareness. Art is the perception of a whole, part relating to part creating harmony. We resonate with that harmony. It is ours. Joseph Campbell writes that when we see a sunset and say "Aha," that is recognition of divinity. It is the same when we say "Aha" to a work of art. "There is a

164 Arthur Waley, *The Way and its Power* quoted in A. Harvey and A. Baring, *The Divine Feminine*, p. 172.

resonance. And what divinity is it? It is *your* Divinity."[165] Artists have rendered Mary according to their times, their beliefs, and their temperament. They touch Wisdom's hidden presence and invite us in. Entering, we sense the wonder of the Feminine Divine. That presence in female Divinities and in the Cosmic Mary is a force responding to the great cry of our world for justice, compassion and love.

What shines through the artists' conceptions represented in these pages is a healing Divine Feminine Presence. From Fra Angelico's *Annunciation* to Frederick Franck's *Original Face* I have sensed Mary's meaning as the Divine Feminine, as Compassionate Mother and Mirror of Justice. In every age She has been present in the art treasures that grace the churches and museums of the world. It has taken me a long time to recognize my need for her as a mirror. Mary is being rescued from a too limited view of her, as "*more* than human and *less* than divine."[166] As we long for the feminine qualities of tenderness, empathy, and love in ourselves and our world, Mary is becoming vitally present again awakening women and men to their gifted selves. She is re-appearing both in her human and cosmic dimension. She is re-appearing as light and dark Madonna. She is re-appearing because we desperately need her in all her aspects, divine and human.

Rejoicing in the Feminine Divine we access our creative potency, our intrinsic power. We enter the temple and at our "inner" altar we dream the mythic truths of our religion onward. Fra Angelico's *Annunciation* (Cortona) speaks to me today

165 Joseph Campbell, "Creativity," in *C.G. Jung and the Humanities*, p. 142.
166 Baring and Cashford, *Myth of the Goddess*, p. 554. The authors write, "If it is true that the feminine principle has not been doctrinally acceptable as a sacred entity for at least 2000 years...is it possible to explain the persistence of devotion to Mary as coming from within the deeper layers of the soul?...Are we not as individuals and as a culture starved for the feminine, suffering from psychic imbalance?...How else make sense of the constant debate over Mary lasting hundreds and hundreds of years, gathering to a crescendo in the last 150 years, which is essentially a debate on how human or divine she is."

though the artist expressed the theology of his time in images representing "sin" and "salvation." Psychologically speaking sin refers to a failure to "know thyself;" salvation means awakening. I have discovered that if the soul experience sparked by a painting or dream image goes deep enough, it pushes us to explore further, unfolding a more personal meaning. Through each artist's imagination the image dances its way into our heart charging our imagination toward the profundities of its message. Its symbols have a mesmerizing effect grounding us in our truth. For as the Roman historian Sallust said of mythic stories, "These things never happened, but they always are."[167]

167 Ann Shearer, "On the Making of Myths," in *Journal of Jungian Theory and Practice*, p. 8.

Coda

Love is recklessness, not reason.
Reason seeks a profit.
Love comes on strong, consuming herself,
Unabashed.

—M. Jelaluddin Rumi

Was it a great leap for me to go from experiencing Fra Angelico's *Annunciation* to experiencing God as Feminine Creative Spirit? Rather than a leap, it seemed a slow deep undercurrent of movement within. Almost imperceptibly I was connecting and re-connecting to my inner "ground," to the Feminine Self, and to God. More than anything else I realize that my personal experience of Fra Angelico's *Annunciation* in my Zürich apartment so long ago inspired hope. I began to feel as if a stuck place in me was giving way to a flow of possibility. I could dream the future into being and somehow I knew all would be well.

Gradually my spiritual journey through Mary into the Divine Feminine led me to savor this hope not as something oriented to the future but rather as a living reality in the present. Cynthia Bourgeault calls this "mystical hope." She writes:

> (Mystical hope) has something to do with presence—not a future good outcome, but the immediate experience of being met, held in communion, by something intimately at hand.[168]

168 Cynthia Bourgeault, *Mystical Hope: Trusting in the Mercy of God,*
 p. 9.

Communing with this Presence is an apt description of a living spirituality. What is our spirituality, really, but living from this inner Source, our spirit which vivifies and gives meaning to our life? Spirituality is not embodied in an outer figure or image. It resides in us or rather we in "it" as a cosmic temple, like the poet Gerard Manley Hopkins' "world mothering air."

I was reminded of this reality when my niece Barbara and I visited Erice, Sicily. We stayed in a small hotel, formerly a house used by priests for vacations, and still owned by the Catholic Diocese. The director, a delightful young man named Salvatore, warmly welcomed us. And occasionally he joined us for the evening meal. It was easy to see that Salvatore was in love. In his halting English he told us that he would be married soon to "my girl," a nurse. Barbara explained that she, too, is a nurse. "Ah, si," he smiled at the connection, and then looked over at me. To explain my relation to Barbara was not easy. In her limited Italian she explained that I was her aunt, not, as he had referred to me earlier, her mother. "What is the Italian word for nun?" Barbara caught my eye. "Suor, I think." Salvatore did not react to the word or to my "mime" of bowed head and praying hands. But finally he got it! "Ah," he smiled proudly as if he had just solved a puzzle. "You are 'monastere incognito!'" This was his way of naming a nun in blue jeans.

When I returned to Boston, I wrote Salvatore an e-mail and signed it "monastere incognito." I reflected on my life years ago when, for a few years, I wore a long black habit, similar in style to 19th century widow's garb. Then, when my religious affiliation was there for all to see, I might have been treated with certain deference or distance or even scorn, depending on what others projected onto me. Being a nun "incognito," I was treated like anyone else. I reflected later that Salvatore's name for me, "monastere incognito" applies to each of us, men, women, married, single, black, white, gay, straight, Hindu, Muslim, Christian, Buddhist, etc. We are walking temples, "monasteries" harboring a treasure, a soul, that is personal, but yet not only ours, for as world soul or unconscious depth, it is shared by all. Teilhard de Chardin expresses it well:

> We are all of us together carried in the one world-womb; yet each of us is our own little microcosm in which the Incarnation is wrought independently with degrees of intensity and shades that are incommunicable.[169]

Sometimes our definition of our self is too small, as are our images of God.

As we have seen, artists, drawing from the energy of the deep unconscious matrix, create images which help us to access energy within our soul, where both demons and angels abide. This movement inward to the imageless does not diminish the power we attribute to the image but we should not equate the image with the energy it provokes. The image *leads* us to life, the riverbed flowing within us. This is what Jung meant when he said in *Psychology and Alchemy*, that many people have the religious images "out there" and not within. Speaking to this point, artist Frederick Franck speculated that in Christianity what survived Resurrection was not Jesus but what Franck called the "Christic," the epiphany of the Ultimate Reality that is the imprint on the ground of every heart."[170] The "Christic" is part of our humanity, our "innate divinity."

It is important in discovering our spirituality to take note of the images, religious or not, that "move" us, those with which we resonate. These tell us something about our unconscious desires, needs and values. Reflecting on the opposites we experience in our life, Jung felt that if God mirrors all of creation, then God must manifest the opposites: good and evil, dark and light, male and female.

It has taken many years for me to agree with Jung on this point. As noted above, I first heard this view when a conference leader proposed that the Genesis serpent (representing the demonic) might symbolize an aspect of God. "Are you kidding?" I blurted out, surprising myself. I had yet to realize that Christianity is a religion of light with the darkness split off: Christ vs.

169 Teilhard de Chardin, "The Mass on the World" *Hymn of the Universe*, p. 28.
170 Frederick Franck, *The Supreme Koan: Confessions on a Journey Inward*, p. 35.

Satan, Mary vs. Eve, heaven vs. hell, good vs. bad. For Jung, op-
posing psychic forces, their conflict and resolution move toward
equilibrium and harmony. The Christian Trinity is one-sided,
extolling spirit, goodness, masculine while splitting off earth,
feminine, and bad (demonic). Religions, like individuals, suf-
fer when they are psychically unbalanced. With an overdose
of masculine and spirit in our religions, we are longing for re-
rooting in the Maternal Feminine.

This is why Jung rejoiced when the Catholic Church pro-
claimed as dogma the Assumption of Mary into heaven. At
least symbolically this was a step in the direction of the Divine
Feminine. Jung wrote:

> The logical consistency of the papal declaration cannot be
> surpassed, and it leaves Protestantism with the odium of be-
> ing nothing but a man's religion which allows no metaphysi-
> cal representation of woman. ... Protestantism has obviously
> not given sufficient attention to the signs of the time which
> obviously point to the equality of women.[171]

Jung wrote this in the 1950's. Protestantism here refers to any
religions or theologies that stress the rational rather than the
mythic and symbolical. While Roman Catholicism is a male
dominated religion with Jesus at its center, it always honored
Mary as his Mother. Though officially she has been "kept in her
place," she has, as a mythic figure, been worshipped by many
as an echoing presence of the ancient Mother Goddesses.

Unfortunately, Catholicism's symbolical nod to the Feminine
over fifty years ago, while including Mary as Female Presence
in the Heavenly Court, has not changed the status of women
from second class participants in its communion of saints. Yet
Jung's insights of many years ago that traditional spiritual-
ity could only divinize half of reality (the masculine, rational,
spiritual), are bearing fruit in the present emerging search for
wholeness and for a recovery of a vital spirituality that includes
the feminine. Current interest in mysticism and the mystical
prayer is one sign that bears this out. The mystic experiences

171 *Answer to Job*, CW Vol. 11, p. 465.

God directly within self where the distance between God and creature is dissolved and the human is divinized.

We have many examples of this God experience in the mystical literature. For example as members of the Beguine movement in the thirteenth and fourteenth centuries, women like Mechthild of Magdeburg and Hadewijch of Antwerp describe in their prayer a sexual union with a youthful Christ image culminating in a union so close as to erase difference. Marguerite Porete, burned by the Inquisition, in Paris in 1310, spoke of her annihilated soul which became "divinized" through union with God.[172] These women influenced the Dominican monk and mystic Meister Eckhart who died during his trial for heresy in 1328. One of his dying prayers was, "I pray to God to rid me of God." This is a prayer to the Godhead, a level of Infinity he intuited as existing beyond the Trinity, (Feminine Wisdom?) to rid him of all lesser images, so that he might be united with the Origin of all.

Psychologically speaking, mystical life involves the "deeper movement of the psyche and vivid experiences of the processes in the collective unconscious."[173] Jung admired Meister Eckhart sensing some connections between himself and the Master, for they both appreciated the depths of the soul where the human and divine meet:

> Well might the writings of this Master lie buried for six hundred years, for 'his time was not yet come.' Only in the nineteenth century did he find a public at all capable of appreciating the grandeur of his mind.[174]

As he immersed himself in Eckhart's thought, Jung came on occasion to feel that Eckhart had experienced the depths of the soul more intensely than had Jung himself. Jung was quick to point out, as Eckhart had, that we are only the "stable" in which God is born. And our "stable" (ego) must be strong enough to contain and not be overwhelmed by the soul's energy.

172 Dourley, *A Strategy for a Loss of Faith*, p. 115.
173 *The Symbolic Life*, CW Vol. 18, p. 98.
174 *Aion*, CW Vol. 9ii, p. 194.

This valuing of the human-divine layers of the soul that we call the mystical life may be lived in solitude or in cloistered religious community where, for centuries, women and men have felt so called. For most of us this inner life is lived "in the world," meeting the challenges and tasks of family and children along with service to the wider community. Of note in this regard is a sermon by Meister Eckhart on the Biblical story of Martha and Mary. (Eckhart, by the way, had taught at the university in Paris and had held administrative positions in his religious order.) In the Martha and Mary Biblical story Mary has often been presented as the "pray-er," captivated by Jesus, sitting at his feet, while her sister, Martha, rushes about cooking and preparing the feast. In contrast to this interpretation, Eckhart calls Martha the mystic who has entered into the depths of God and is thus energized to live "in the world" an active life of service, while Mary must remain seated near the Jesus figure still awaiting this grace.[175]

Eckhart was well aware that service to others is the fruit of a contemplative outlook on life. Images and symbols open us to the transcendent, pointing the way to this goal. And although the Catholic Church is a treasure house for symbols, (a few of which we have explored in Chapter One) their revitalization must be an ongoing renewal of the tradition. "No set of religious symbols can be made to live again until humanity recovers its symbolic sense—the meaning of the symbols will live again, when, like the mystic, the individual experiences their power and its source directly."[176] Each of us is a mystic as we explore the deeper layers of soul, as we honor its messages as they come in dreams, as insights and visions, as we respond to each other as "temple," welcoming the God who becomes incarnate within us.

This psychological "going beneath" the Mary image has opened a way for me to further explore the mythic images or

175 Dourley, *A Strategy for a Loss of Faith*, p. 132.
176 John P. Dourley, *Jung and the Religious Alternative: The Rerooting*, p. 266.

constructs through which religions not my own present their story. Since we must use image and metaphor to approach God's reality, why can we not accept each other's "way" to that Reality? For me this question has surfaced repeatedly during my spiritual quest. Why can we not honor the other's religious images and stories? Jungian analyst James Hollis wonders if we could imagine during past religious wars people shouting as they killed the infidel, "My metaphor, my symbolic construct has more potency ... than your metaphor or symbolic construct?"[177] When we literalize our religious stories we distance ourselves from soul, the God within. We deny ourselves our wealth. When we take back our projections on our religious figures, we "energize" the spirit within and thus, recover our treasure. We worship in spirit and in truth.

My experience of Mary in her symbolic imagery and in her depth psychological meaning has led me to a more mystical prayer, for I now experience within me the "ground" which it symbolizes. And if the wisdom we gain through momentary encounters with our soul is the only basis for compassion, then I am becoming a more empathic person. I may lose a sense of this inner Presence but I know it is there, recoverable. The image of Mary fades into a nothingness *felt* as feminine, mothering, holding. In communing with this soul depth I receive myself.

And here I meet others, for here we unite with each other and all humanity in our hopes, our suffering, and need for healing. Here we participate in the psyche's fecundity, ever renewing, ever creating. Is the Maternal Wisdom, *inner* Goddess, creating something new in us? In our world? It may be that *her* Spirit stirs in the world to destroy worn out attitudes towards our self and each other, to revitalize sterile religious structures, and to foster the new. Her compassion and love bind together and heal. Teilhard expresses it well:

177 James Hollis, *Finding Meaning in the Second Half of Life*, p. 190.

> Only love can bring individual beings to their
> perfect completion as individuals, by uniting
> them one with another, because only love
> takes possession of them and unites them by
> what lies deepest in them.[178]

Participating in her Spirit, we may find ourselves exploring the
treasures that are ours whether in the Buddhist, Judeo-Chris-
tian, Muslim or Hindu myths into which we were born. Then
we may own that *all* religious revelations are psychic realities.
There, within the soul, we may discover our gods, and their
matrix, the One Source that Mothers us all.

178 Teilhard de Chardin, "Pensees," no. 72 in *Hymn of the Universe*, p.
 145.

BIBLIOGRAPHY

Adler, Gerhard. *The Living Symbol.* New York: Pantheon Books, 1961.

Armstrong, Karen. *A Short History of Myth.* Edinburgh; Canongate, 2005.

Asper, Kathrin. *The Abandoned Child Within: On losing and Regaining Self-Worth.* Tr. by Sharon E. Rooks. New York: Fromm International Publishing Corporation, 1993.

Balasuriya, Tissa. *Mary and Human Liberation.* Ed. Helen Stanton. Harrisburg: Trinity Press International, 1997.

Baring, A. and Cashford, J. *The Myth of the Goddess: Evolution of an Image.* London: Penguin Books, 1991.

Barker, Margaret. *On Earth as it is in Heaven: Temple Symbolism in the New Testament.* Edinburgh: T & T Clark, 1995.

Barker, Margaret. *The Great High Priest: Temple Roots of Christian Liturgy.* London, T & T Clark, 2003.

Barker, Margaret. *The Revelation of Jesus Christ.* Edinburgh: T & T Clark, 2000.

Barnstone, Willis, Ed. *The Other Bible.* San Francisco: Harper & Row, 1984.

Belting, Hans. *Likeness and Presence: A History of the Image before the Era of Art.* Chicago: University of Chicago Press, 1994.

Benjamin, Walter. *Illuminations.* New York: Harcourt, Brace & World, 1968.

Berry, Patricia. "What's the Matter with Mother?" in *Echo's Subtle Body: Contributions to an Archetypal Psychology.* Texas: Spring Publications, Inc., 1982.

Boff, Leonardo. *The Maternal Face of God.* San Francisco: Harper & Row, 1897.

Bourgeault, Cynthia. *Mystical Hope: Trusting in the Mercy of God.* Cambridge MA: Cowley Publications, 2001.

Burke, Marcus B. "Why Art needs Religion, Why Religion needs the Arts," in *Reluctant Partners, Art and Religion in Dialogue.* Ed. Ena Giurescu Heller. New York: The Gallery at the American Bible Society, 2004.

Campbell, Joseph. "Creativity," in *C.G. Jung and the Humanities.* Ed. Karin Barnaby. Princeton: Princeton University Press, 1990.

———— *The Mythic Image.* Princeton: Princeton University Press, 1974.

Casey, Thomas G., S.J. *Humble and Awake: Coping with our Comatose Culture.* Springfield, Illinois: Templegate Publisher, 2004.

Chatzidakis, Manolis. *Byzantine Museum.* Athens: Ekdotike Athenon S.A., 1981.

Coakley, Sarah. *Powers and Submissions: Spirituality, Philosophy and Gender.* Malden, MA: Blackwell Publishers, Inc., 2002.

Condren, Mary. *The Serpent and the Goddess: Women, Religion and Power in Celtic Ireland.* Dublin: New Island Books, 2002.

Conzelmann, Hans. "The Mother of Wisdom," in *The Future of Our Religious Past.* Ed. James M. Robinson. New York: Harper & Row, 1971.

Craighead, Meinrad. *The Mother's Songs: Images of God the Mother.* New York: Paulist Press, 1986.

Cunneen, Sally. *In Search of Mary: The Woman and the Symbol.* New York: Ballantine Books, 1996.

Daly, Mary. *Beyond God the Father.* Boston: Beacon Press, 1973.

Dillenberger, Jane. *The Religious Art of Andy Warhol.* New York: Continuum, 1998.

Dourley, John P. *A Strategy for a Loss of Faith: Jung's Proposal.* Toronto: Inner City Books, 1992.

―――― *Jung and the Religious Alternative: The Rerooting.* Lewiston, New York: Edwin Mellen Press, 1995.

―――― *The Goddess, Mother of the Trinity: A Jungian Implication.* Lewiston, New York: Edwin Mellen Press, 1990.

Drewermann, Eugen. *Discovering the God Child Within: A Spiritual Psychology of the Infancy of Jesus.* New York: Crossroad, 1994.

Drury, John. *Painting the Word: Christian Pictures and their Meanings.* New Haven: Yale University Press, 1999.

Ebertshauser C.H., Haag H., Kirchberger J.H., & Solle, D. *Mary: Art, Culture, and Religion through the Ages.* New York: Crossroad, 1997.

Edinger, Edward. *Ego and Archetype: Individuation and the Religious Function of the Psyche.* Baltimore: Penguin Books, Inc., 1973.

Eiseman, Fred and Margaret. *Sekala & Niskala.* Singapore: Periplus Editions, 1988.

Eliot, T.S. *Collected Poems.* New York: Harcourt, Brace and Company, 1963.

Elizondo, Virgilio. *Guadalupe: Mother of the New Creation.* New York: Orbis Books, 2002.

Fiorenza, Elisabeth Schüssler. *Sharing Her Word.* Boston: Beacon Press, 1998.

Franck, Frederick. *Art as a Way.* New York: Crossroad, 1981.

―――― *The Supreme Koan: Confessions on a Journey Inward.* New York: Crossroad, 1982.

Franklin, David. *The Art of Parmigianino.* New Haven: Yale University Press and National Gallery of Canada, 2003.

Galland, China. *Longing for Darkness: Tara and the Black Madonna.* New York: Viking Penguin, 1990.

Gentle, Judith. *Jesus Redeeming in Mary.* New York: Montfort Publications, 2003.

Gustafson, Fred. *The Black Madonna*. Boston: Sigo Press, 1990.

Harding, Esther. *Women's Mysteries, Ancient and Modern*. Boston: Shambhala, 1971.

Harrison, Barbara G. "My Eve, My Mary." *Newsweek*, August 25, 1997.

Hadewijch. *Hadewijch: The Complete Works*. Tr. Mother Columba Hart. Classics of Western Spirituality (SPCK, London, 1980.)

Harvey, A. and Baring, A. *The Divine Feminine: Exploring the Feminine Face of God Throughout the World*. Berkeley: Conari Press, 1996.

Hillman, James. *The Force of Character*. New York: Ballantine Books, 2000.

Hollis, James. *Finding Meaning in the Second Half of Life*. New York: Gotham Books, 2005.

Hopkins, Gerard Manly. *God's Grandeur and Other Poems*. New York: Dover Publications, Inc., 1995.

Irenaeus. *Adversus Haereses, III*, 22, 4.

Johnson, Elizabeth A. *She Who Is: The Mystery of God in Feminist Theological Discourse*. New York: Crossroad Publishing , 1993.

Jonas, H. *The Gnostic Religion*. Boston: Beacon Press, 2001.

Jung, C.G. *Aion*, CW, Vol. 9ii. Princeton: Princeton University Press, 1959.

——— *Answer to Job*, CW, Vol. 11. Princeton: Princeton University Press, 1958.

——— *Alchemical Studies*, CW, Vol. 13. Princeton: Princeton University Press, 1967.

——— *Analytical Psychology Seminar*. Zürich: (Privately Printed), 1925.

——— *Memories, Dreams, Reflections*. Ed. Aniela Jaffe. New York: Random House, 1961.

——— *Mysterium Coniunctionis*. CW, Vol. 14. Princeton: Princeton University Press, 1963.

——— *Psychology and Alchemy*, CW, Vol. 12. Princeton: Princeton University Press, 1953.

——— *Psychology and Religion*, CW, Vol. 11. Princeton: Princeton University Press, 1958.

——— *Symbols of Transformation*, CW, Vol. 5. Princeton: Princeton University Press, 1956.

——— *The Spirit in Man, Art, and Literature*, CW, Vol. 15. Princeton: Princeton University Press, 1966.

——— *The Symbolic Life*, CW, Vol. 18. Princeton: Princeton University Press, 1950.

——— *The Visions Seminars*, 1, p. 72 quoted in *Primary Speech: A Psychology of Prayer*, Ann & Barry Ulanov. Atlanta: John Knox Press, 1982.

Kalsched, Donald. *The Inner World of Trauma.* New York: Routledge, 1997.

Kassel, Maria. "Mary and the Human Psyche," in Hans Küng and Jürgen Moltmann, *Mary in the Churches.* New York: Seabury, 1983.

Kristeva, Julia. *The Kristeva Reader.* Ed. Toril Moi. New York: Columbia University Press, 1986.

Layard, John. *The Virgin Archetype.* Zürich: Spring Publications, 1972.

Lightbrown, Ronald. *Piero della Francesca.* New York: Abbeville Press, 1992.

Lundquist, John M. *The Temple: Meeting Place of Heaven and Earth.* London: Thames & Hudson, Ltd., 1993.

Lusseyran, Jacques. "Jeremy," in *Parabola Magazine*, Summer, Vol. XI, no 2. 1998.

Maggio, Theresa. *The Stone Boudoir: Travels through the Hidden Villages of Sicily.* Cambridge, MA, Perseus Publishing, 2002.

Manteau-Bonamy, H.M. *Immaculate Conception and the Holy Spirit: The Marian Teachings of St. Maximilian Kolbe.* Libertyville, Ill: Marytown Press, 2001.

Markale, Jean. *Cathedral of the Black Madonna: The Druids and the Mysteries of Chartres.* Vermont: Inner Traditions, 2004.

—— *The Great Goddess: Reverence of the Divine Feminine from the Paleolithic to the Present.* Trans. by Jody Gladding. Rochester, Vermont: Inner Traditions, 1999.

Matthews, Caitlin. *Sophia, Goddess of Wisdom.* New York: HarperCollins, 1991.

McFague, Sallie. *Models of God: Theology for an Ecological Nuclear Age.* Philadelphia: Fortress Press, 1987.

Meier, C.A. *Soul and Body: Essays on the Theories of C.G. Jung.* San Francisco: Lapis Press, 1986.

Menninger, Karl. "Hope," in *The American Journal of Psychiatry* December, 1959.

Merton, Thomas. *Conjectures of a Guilty Bystander.* New York: Doubleday & Co., 1966.

Mor, B. & Sjoo, M. *The Great Cosmic Mother: Rediscovering the Religion of the Earth.* San Francisco: HarperCollins, 1976.

Murk-Jansen, Saskia. *Brides in the Desert.* New York: Orbis Books, 1998.

Naegle, Richard. Seminar notes from Guild for Psychological Studies, San Francisco, 1995.

Nelson, Gertrud M. *Here All Dwell Free: Stories to Heal the Wounded Feminine.* New York: Doubleday, 1991.

Neumann, Erich. *The Great Mother.* Princeton: Princeton University Press, 1963.

Norris, Kathleen. "Annunciation," in *Watch for the Light: Readings for Advent and Christmas.* East Sussex: Plough Publishing House, 2001.

Pagels, Elaine. *The Gnostic Gospels.* New York: Vintage Books, 1981.

Pelikan, Jaroslav. *Mary through the Centuries: Her Place in History of Culture.* New Haven: Yale University Press, 1996.

Piggott, J and Bedrick, P. *Japanese Mythology.* New York: Harper & Row, 1982.

Remen, Rachel Naomi, *Kitchen Table Wisdom.* New York: Riverhead Books, 1996.

Reuther, Rosemary R. "Patristic Spirituality and the Experience of Women in the Church," in *Western Spirituality: Historical Roots, Ecumenical Routes.* Ed. Matthew Fox. Indiana: Fides/Claretian.

Rizzuto, Ana-Maria. *The Birth of the Living God: A Psychoanalytic Study.* Chicago: University of Chicago Press, 1981.

Robinson, John. "Very Goddess, Very Man," in *Images of the Feminine in Gnosticism.* Ed. Karen L. King. Philadelphia: Fortress Press, 1988.

Rothenberg, Rose-Emily. *The Jewel in the Wound: How the Body expresses the Needs of the Psyche and offers a Path to Transformation.* Wilmette, Illinois: Chiron Publications, 2001.

Sarton, May. "Annunciation," in *A Grain of Mustard Seed.* New York: W.W. Norton & Co., 1971.

Schillebeeckx, Edward. *Mary, Mother of the Redemption.* New York: Sheed and Ward, 1964.

Schiller, Gertrude. "The Annunciation of Mary" in *Iconography of Christian Art.* Greenwich, Conn: N.Y. Graphics Society, Ltd., 1971.

Shearer, Ann. "On the Making of Myths," in *Journal of Jungian Theory and Practice.* New York: C.G. Jung Institute Vol. 6, No. 2, 2004.

Stein, Murray. "Individuation: Inner Work" in *Journal of Jungian Theory and Practice.* New York, C.G. Jung Institute Vol. 7, no. 2, 2005).

Teilhard de Chardin. "Pensees," no. 72 in *Hymn of the Universe.* New York: Harper & Row, 1961.

———— "The Eternal Feminine" in *The Prayer of the Universe.* Trans. Rene Hague. New York: Harper & Row, Inc., 1968.

———— "The Mass on the World" *Hymn of the Universe.* New York: Harper & Row, 1961.

Teresa of Avila. *The Interior Castle.* Trans. K. Kavanaugh, O. Rodriguez, OCD. New York: Paulist Press, 1979.

Twain, Mark, "Extracts from Adam's Diary," in *The Unabridged Mark Twain,* Vol. 2, ed. Lawrence Teacher. Philadelphia: Running Press, 1979.

Ulanov, Ann Bedford. *The Feminine in Jungian Psychology and in Christian Theology.* Evanston: Northwestern University Press, 1971.

———— *The Healing Imagination: The Meeting of Psyche and Soul.* New York: Paulist Press, 1991.

Wach, Kenneth. *Salvador Dali.* New York: Harry N. Abrams, Inc., 1996.

Walker, Barbara G. *Woman's Dictionary of Symbols and Sacred Objects.* San Francisco: HarperCollins, 1988.

Warner, Marina. *Alone of All Her Sex.* New York: Alfred A. Knopf, 1976.

Winnicott, D. "Narcissism and the Search for Interiority," *Quadrant,* Vol. 13 (1980). (Quoted by Donald Kalsched.)

Yeats, W.B. *The Poems.* Ed Richard J. Finneran. New York: Scribner, 1989.

Many thanks to all who have directly or indirectly granted permission to quote and display their work, including:

The Gnostic Religion by Hans Jonas. Copyright © 1958 by Hans Jonas. Reprinted with permission of Beacon Press, Boston.

G.M. Hopkins, *God's Grandeur and Other Poems,* Ed. Thomas Crofts. Used by permission of Dover Publications, Inc. 1995.

"Annunciation", from A GRAIN OF MUSTARD SEED by May Sarton. Copyright ©1971 by May Sarton. Used by permission of W.W. Norton & Company, Inc.

Images

Cover. Boštík, Václav. *The Virgin and Infant Jesus*, (Oil on cardboard 50 x 30 cm.) Photograph © National Gallery in Prague, 2008.

1. Angelico, Fra (1387-1455). Annunciation. Museo Diocesano, Cortona, Italy. Photo Credit: Scala / Art Resource, NY.

2. Bruyn, Bartel. *The Annunciation* (16th Century) Rheinisches Landesmuseum, Bonn, Germany.

3. Raymo, Ann. *Annunciation*, c.1960 (charcoal on paper) by Ann Raymo (fl.1960) Private Collection/ Photo © Boltin Picture Library/ The Bridgeman Art Library.

4. Dürer, Albrecht. *The Annunciation*, c.1526 (pen and ink). Musée Condé, Chantilly. Photo © The Bridgeman Art Library.

5. Tanner, Henry Ossawa. *The Annunciation*. Philadelphia Museum of Art. Purchased with the W.F. Wilstach Fund, 1899.

6. Armenian Manuscript 17th Century, Annunciation (motif). British Museum, London. © British Library Board, Picture no. 1022251.341.

7. Poussin, Nicolas. *The Annunciation*, c.1657. Photo © The National Gallery Picture Library, London.

8. Parmigianino (Girolamo Francesco Maria Mazzola, Italian, Parma, 1503-1540), *The Annunciation*, ca. 1523+1540; Oil on wood 33 3/8 x 23 1/8 in. (84.8 x 58.7 cm): The Metropolitan Museum of Art, Purchase, Gwynne Andrews Fund, James S. Deely Gift, special funds, and other gifts and bequests, by exchange, 1982 (1982.319) Image © The Metropolitan Museum of Art.

9. Duccio (di Buoninsegna) (c.1260-1319). *Annunciation of the Death of the Virgin*. From the upper section of the Maesta altarpiece. Museo dell'Opera Metropolitana, Siena, Italy. Photo Credit: Scala / Art Resource, NY.

10. Dali, Salvador. *Annunciation* 1956 (Ink) © 2008 Salvador Dali, Gala-Salvador Dali Foundation / Artist Rights Society (ARS), New York.

11. Warhol, Andy. Details of Renaissance Paintings (Leonardo da Vinci, The Annunciation, 1472), 1984. Founding collection, The Andy Warhol Museum, Pittsburg. © 2008 The Andy Warhol Foundation for the Visual Arts / ARS, New York.

12. Leonardo da Vinci (1452-1519). *Annunciation.* Post-cleaning. Ca. 1472. Oil on wood. 38 5/8 x 85 3/8 (98 x 217 cm). Uffizi, Florence, Italy. Photo Credit: Scala/Ministero per i Beni e le Attivita culturali / Art Resource, NY.

13. *Virgin of Tenderness.* Original icon by Angelos (c. 1600), Byzantine Museum, Athens. Photo Credit: Mel Mathews.

14. The Black Madonna of Einsiedeln by permission of Father Dr. Odo Lang, Librarian, Benedictine Abbey of Our Lady of Einsiedeln / Switzerland Photo: P. Damian Rutishauser.

15. The Madonna of Rocamodour. Freedberg, David. *Power of Images: Studies in the History and Theory of Response.* Chicago. © University of Chicago Press, 1989, p. 28. Photo by Author.

16. Dormition de la Vierge, Chartres Cathederal. Photo Credit: Editions HOUVET.

17. Piero della Francesca (c.1420-1492). *The Madonna del Parto* (Virgin with two angels). ca.1460. Fresco, 260 x 203 cm. Post-restoration. Cappella del Cimitero, Monterchi, Italy. Photo Credit: Scala / Art Resource, NY.

18. Piero della Francesca (c.1420-1492). Polytych of the *Madonna della Misericordia.* Photo: George Tatge, 1993. Pinacoteca Comunale, Sansepolcro, Italy. Photo Credit: Alinari / Art Resource, NY.

19. Vierge Ouvrante (closed). c.1400. Wood and polychrome. Western Prussia/Germany. Inv. Cl. 12060. Photo: G. Blot. Musée National du Moyen Age - Thermes de Cluny, Paris, France. Photo Credit: Reunion des Musées Nationaux / Art Resource, NY.

20. Vierge Ouvrante (open). c.1400. Wood and polychrome. Western Prussia/Germany. Inv. Cl. 12060. Photo: G. Blot. Musée national du Moyen Age - Thermes de Cluny, Paris, France. Photo Credit: Reunion des Musées Nationaux / Art Resource, NY.

21. Original Face (closed). Variation on 15th c. Ouvrante by permission of Claske and Lukas Frank. Photo: Luz Piedad Lopez.

22. Original Face (open). Variation on 15th c. Ouvrante by permission of Claske and Lukas Frank. Photo: Luz Piedad Lopez.

INDEX

A

Adler, Gerhard 33
 The Living Symbol 33
alchemy 132-133
Alexander 27
Amaterasu 85
Amun 28
Aphrodite 30, 109
Apollo 74
archetypal feminine 8
Aristotle 21
Armstrong, Karen 2, 126
 A Short History of Myth 2, 126,
Artemis 80-81, 97
 as Moon Goddess 97
 of Ephesus 80
Asklepios 20, 74
Asper, Kathrin 135
 The Abandoned Child Within
 135
Athena 25, 80

B

Balasuriya, Tissa 15
 Mary and Human Liberation 15
Baring, Anne 7, 21, 25, 29, 52,
 74, 83, 96-97, 119, 131,
 134, 139-140
 The Divine Feminine: Exploring
 the Feminine Face of God
 Throughout the World 25,
 119, 139
Baring, Anne and Jules Cashford
 The Myth of the Goddess 7, 29
Barker, Margaret 100-101, 122
 On Earth as it is in Heaven 100
 The Great High Priest 101
 The Revelation of Jesus Christ
 122
Barnstone, Willis
 The Other Bible 49
Becket, Thomas 88
Beguine movement 147

Belting, Hans
 Likeness and Presence 80
Benjamin, Walter
 Illuminations 13
Berry, Patricia
 "What's the Matter with Moth-
 er?" 52-53, 129-130
Black Madonna 2, 8-9, 49, 71,
 82-86, 88-89, 110, 114
 of Einsiedeln 73, 82, 86, 89, 93
Black Virgin 73, 84, 87-89
 of Rocamadour 73, 87-89
Boff, Leonardo
 The Maternal Face of God 112
Botticelli, Sandro
 Virgin and Child 4
Bourgeault, Cynthia
 Mystical Hope: Trusting in the
 Mercy of God 143
Bruyn, Bartel
 The Annunciation 21-22, 28
Buddha 26, 46, 86, 133
Burke, Marcus B.
 "Why Art needs Religion, Why
 Religion needs the Arts," 4

C

caduceus 20-21
Campbell, Joseph
 C.G. Jung and the Humanities
 139-140
 The Mythic Image 3, 24, 26
Casey, Thomas G. 44
 Humble and Awake: Coping with
 our Comatose Culture 44
Cashford, Jules 7, 21, 29, 52, 74,
 83, 96-97, 131, 134, 140
Ceres 81
Chartres Cathedral 49, 84, 88
Chatzidakis, Manolis
 Byzantine Museum 75
Cicero 80
Coakley, Sarah 33
 Powers and Submissions: 33

Collyridians 96
Condren, Mary
 The Serpent and the Goddess 21
Confraternity of Santa Maria
 106-107
Conzelmann, Hans
 "The Mother of Wisdom," 109
Corbin, Henry 4
Craighead, Meinrad
 *The Mother's Songs: Images of
 God the Mother* 96
Cunneen, Sally
 In Search of Mary 6-7, 23, 57,
 89-90, 96, 103, 120
Cybele 59-60

D

daemon 32
Dali, Salvador 63-67
Daly, Mary
 Beyond God the Father 26
da Vinci, Leonardo 67-69
Day of Atonement 100
Delphi 19, 74, 80, 127
Delphic Oracle 19
Demeter 50, 73-74, 84, 90-91
Dillenberger, Jane
 The Religious Art of Andy Warhol
 69-70
Divine Child 8
Divine Feminine 6, 8-9, 25, 50,
 60, 74, 85, 107, 119, 125,
 136, 138-140, 143, 146
Divine Mother 50, 73
Dourley, John P.
 *A Strategy for a Loss of Faith:
 Jung's Proposal* 7, 148
 *Jung and the Religious Alternative:
 the Rerooting* 148
 *The Goddess, Mother of the Trin-
 ity: A Jungian Implication* 6
Drewermann, Eugen
 Discovering the God Child Within
 28
Druids 49, 88

Drury, John
 *Painting the Word: Christian Pic-
 tures and their Meanings* 52
Duccio di Buoninsegna 60-61, 63
Dürer, Albrecht
 Annunciation 35, 38-39, 41-42

E

Earth Mother 49-50, 52, 74, 95
Edinger, Edward
 Ego and Archetype 16, 29, 40,
 125
Eiseman, Fred and Margaret
 Sekala & Niskala 41
Eliot, T.S.
 Collected Poems 49-50
Eostre 66

F

Feast of Mary's Nativity 91
Fiorenza, Elisabeth Schüssler
 Sharing Her Word 120
Fra Angelico v, 1, 4, 9, 12-14, 17-
 19, 24, 35, 38, 57, 140, 143
Franck, Frederick 9-10, 94-95,
 102, 115, 120-123, 125,
 137-138, 140, 145
 Art as a Way 138
 The Original Face 10, 102, 120-
 122, 125-126
 *The Supreme Koan: Confessions
 on a Journey Inward* 145
Franklin, David
 The Art of Parmigianino 57

G

Gaia 17, 52, 129-130
Galland, China
 *Longing for Darkness: Tara and
 the Black Madonna* 84-85,
 89
Gentle, Judith
 Jesus Redeeming in Mary 92

Giovanni de Paolo
 Expulsion and Annunciation 14
Gnostic 23, 40-41, 86, 111, 115,
 122
Gnostic Gospels 111, 115
Gnosticism 86, 112
Gnostic tale
 "The Hymn of the Pearl." 40
Great Mother 6-7, 10, 20-21, 48,
 50, 71, 83, 95, 101, 106,
 115, 118, 130, 134
Gustafson, Fred
 The Black Madonna 83-84, 89

H

Hadewijch of Antwerp, 147
 Hadewijch: The Complete Works
 119
Harding, Esther
 Women's Mysteries: Ancient and
 Modern 136
Harrison, Barbara G.
 "My Eve, My Mary." 23-24
Harvey, A.
 The Divine Feminine: Exploring
 the Feminine Face of God
 Throughout the World. 25,
 119, 139
Hathor 25
Hermes 21, 57, 58
Hildegard of Bingen 99
Hillman, James
 The Force of Character 124,
Hollis, James
 Finding Meaning in the Second
 Half of Life 149
Holy of Holies 100
Hopkins, Gerard Manly 110-111,
 144
 God's Grandeur and Other Poems
 111
Horus 26
Howes, Elizabeth 13, 16
"Hymn of the Pearl" 32, 45, 124

I

Inanna 25, 52, 90, 108
Irenaeus 91-92
 Adversus Haereses 92
Ishtar 25, 91, 95
Isis 25-26, 30, 83-85, 90, 108-110

J

Jaffe, Aniela 128, 132-133
Johnson, Elizabeth A.
 She Who Is 8, 33-34, 73
Jonas, II.
 The Gnostic Religion 40
Jung, C.G.
 Aion 147
 Alchemical Studies 94
 Analytical Psychology Seminar 34
 Answer to Job 146
 Memories, Dreams, Reflections 5,
 100, 132
 Mysterium Coniunctionis 3, 5, 94
 Psychology and Alchemy 145
 Psychology and Religion 63, 113
 Symbols of Transformation 7
 The Spirit in Man, Art, and Litera-
 ture 54
 The Symbolic Life 7, 147
 The Visions Seminars 79
Juno 66

K

Kalsched, Donald
 The Inner World of Trauma 4
Kandinsky 81
Kassel, Marie
 "Mary and the Human Psyche"
 136-137
Kristeva, Julia
 The Kristeva Reader 106

L

Layard, John
 The Virgin Archetype 25

Lightbrown, Ronald
 Piero della Francesca 9-10, 101,
 103, 105-106, 115
Lundquist, John M.
 *The Temple: Meeting Place of
 Heaven and Earth* 101
Lusseyran, Jacques
 "Jeremy" 78

M

Manteau-Bonamy, H.M.
 *Immaculate Conception and the
 Holy Spirit: The Marian
 Teachings of St. Maximilian
 Kolbe* 112
Marduk 96
Markale, Jean
 *Cathedral of the Black Madonna:
 The Druids and the Mysteries
 of Chartres* 88
 *The Great Goddess: Reverence of
 the Divine Feminine from
 the Paleolithic to the Present*
 59-60, 74
Mars 66
Mary
 Assumption of 112-113, 146
Mary as
 Dark Mother 114
 Divine Feminine 6
 Divine Wisdom-Sophia 108
 Face of God 112
 light and dark Madonna 10,
 140
 matrix of a new creation 137
 Mirror of Justice 9, 85, 140
 Mother and Wisdom 8
 Mother God 10, 21, 79-80, 96,
 115, 135
 Mother of God 10, 79, 94, 96,
 104
 Mother of the Universe 9
 Primordial Mother 10, 73, 94
 Queen of Heaven xii, 9, 96-98,
 104, 113, 122, 135

Sophia Wisdom 9, 110, 114,
 134
Sorrowful Mother 73, 89, 91,
 114
Sorrowful One 10, 94
Temple v, 10, 99
Virgin Mother 2, 25-26
Wisdom Sophia 2, 94, 102,
 109, 125, 133
Matthews, Caitlin
 Sophia, Goddess of Wisdom 84
May, Rollo 53
McFague, Sallie
 *Models of God: Theology for an
 Ecological Nuclear Age* 108
Mechthild of Magdeburg 147
Meier, C.A. 20, 74
 *Soul and Body: Essays on the
 Theories of C.G. Jung* 20
Meister Eckhart 3, 147-148
Menninger, Karl
 "Hope" 66
Mercurius 133
Mercury 21, 58
Merlin 133
Merton, Thomas
 Conjectures of a Guilty Bystander
 27
Mircea Eliade 66
mirror 8, 77-78, 83, 85, 125, 131,
 138, 140
Misericordia 10, 101, 104-107,
 111, 115
Monk Kidd, Sue
 The Secret Life of Bees 113
Moon Mother 97, 135-136
Mor, B. & Sjoo, M
 The Great Cosmic Mother 50
Mother
 longing for 135
Murk-Jansen, Saskia
 Brides in the Desert 119

N

Naegle, Richard 2

Narcissus 77
Nelson, Gertrud M.
Here All Dwell Free 24
Neumann, Erich
The Great Mother 70, 115
Norris, Kathleen
"Annunciation" 41

O

O'Connor, Flannery
"A Temple of the Holy Ghost"
108
Osiris 26
Our Lady of Guadalupe 107

P

Pagels, Elaine
The Gnostic Gospels 111, 115,
Pandora 59
Parmigianino 56-57
Pelikan, Jaroslav
Mary through the Centuries 9
Persephone 90
Philo 21
philosopher's stone 128, 131
Piero della Francesca
Madonna del Parto 9-10, 101-
103
Mater Misericordia 9-10, 101,
104-106, 115
Piggott, J and Bedrick, P.
Japanese Mythology 85
Plato 27
pomegranates 103
Pope Benedict XIV 118
Pope Pius XII 112
Poussin, Nicolas 37, 51-52
prostitute 59
Pythagoras 27
Pythia 74

Q

Quan Yin 106-107, 138
Queen Maya 26

R

Raphael 81
Raymo, Ann
Annunciation 30-31
Remen, Rachel Naomi
Kitchen Table Wisdom 15
Reuther, Rosemary R. 21
Rizzuto, Ana-Maria
The Birth of the Living God 93
Robinson, John
"Very Goddess, Very Man" 112
Rocamadour 73, 86-89, 93
Rothenberg, Rose-Emily
The Jewel in the Wound 131
Rumi 59, 119, 143

S

Sarton, May
"Annunciation" 17-18, 41
Schillebeeckx, Edward
Mary, Mother of the Redemption
8
Schiller, Gertrude 28
Sedes Sapientia 88
serpent 14-16, 18-21, 23, 40, 145
Serpent Goddess 20
serpent priestess 19
Shearer, Ann
"On the Making of Myths" 141
Silesius, Angelus 3, 94
Sophia
"Stone of Exile" 137
St. Augustine 41
Stein, Murray
"Individuation: Inner Work"
138
Sulevia 88
Susano 85
Suzuki, D.T. 124

T

Tammuz 91
Tanner 37, 43, 45-46
Tao Te Ching 139
Tara 84-86

Teilhard de Chardin
 "Pensees" 150
 "The Eternal Feminine" in *The
 Prayer of the Universe* 125,
 "The Mass on the World" 144-
 145
temple at Delphi 74
Teresa of Avila
 The Interior Castle 131
Tibetan Book of the Dead 63
Tillich, Paul 4
Twain, Mark
 The Unabridged Mark Twain 15

U

Ulanov, Ann Bedford
 *Primary Speech, A Psychology of
 Prayer,* 79
 *The Feminine in Jungian Psycholo-
 gy and in Christian Theology*
 18, 54, 130
 The Healing Imagination 4
Uranos 52-53

V

Vierge Ouvrante 10, 102, 115-123,
 125-126
Virgin of Tenderness 10, 73, 75-
 76, 80, 83, 89, 93, 138

W

Walker, Barbara G.
 *Woman's Dictionary of Symbols
 and Sacred Objects* 19, 49,
 55, 66, 78, 97
Warhol, Andy 35, 67-70
Warner, Marina
 Alone of All Her Sex 27
Whore of Babylon 135
Winnicott, Donald
 "Narcissism and the Search for
 Interiority" 77-78
Wisdom-Sophia 93, 108, 114

Y

Yeats, W.B. 125

Z

Zeus 80-81, 90

Also from Fisher King Press

The Creative Soul
 by Lawrence H. Staples

ISBN 978-0-9810344-4-7
Jungian Perspective

Guilt with a Twist
 by Lawrence H. Staples

ISBN 978-0-9776076-4-8
Jungian Perspective

Enemy, Cripple & Beggar
 by Erel Shalit

ISBN 978-0-9776076-7-9
Jungian Perspective

Resurrecting the Unicorn
 by Bud Harris

ISBN 978-0-9810344-0-9
Jungian Perspective

The Sister from Below
 by Naomi Ruth Lowinsky

ISBN 978-0-9810344-2-3
Jungian Perspective

Journey to the Heart
 by Nora Caron

ISBN 978-0-9776076-6-2
Literary Fiction

Timekeeper
 by John Atkinson

ISBN 978-0-9776076-5-5
Literary Fiction

The Malcolm Clay Trilogy
 by Mel Mathews

Literary Fiction

LeRoi
Menopause Man
SamSara

ISBN 978-0-9776076-0-0
ISBN 978-0-9776076-1-7
ISBN 978-0-9776076-2-4

Order directly from Fisher King Press
Within the U.S. call 1-800-228-9316
International call +1-831-238-7799
www.fisherkingpress.com

Printed in the United States
219424BV00001B/5/P

9 780981 034416